IMAGES
of America

THE KASHUBIAN
POLISH COMMUNITY OF
SOUTHEASTERN MINNESOTA

DIE OSTSEE

Überarbeitung des Entwurfs v. 1819
1833

This map was printed prior to 1918. During the time of Winona's Polish migration, the land of exodus was under Prussian occupation. Prussianization involved changing names of cities, and even, at times, of families from Polish to German spelling. Present-day difficulty in finding cities of origin is due to the fact that the names of those cities of emigration are not on any of the current maps, so you will not find Konitz, Behrend, and Danzig anymore. But you will now find Chojnice, Koscierzyna, and Gdansk in their place.

IMAGES
of America

THE KASHUBIAN
POLISH COMMUNITY OF
SOUTHEASTERN MINNESOTA

The Polish Cultural Institute

ARCADIA
PUBLISHING

Published by Arcadia Publishing
Charleston, South Carolina

Library of Congress Catalog Card Number: 2001091372

For all general information contact Arcadia Publishing at:
Telephone 843-853-2070
Fax 843-853-0044
E-Mail sales@arcadiapublishing.com
For customer service and orders:
Toll-Free 1-888-313-2665

Visit us on the Internet at www.arcadiapublishing.com

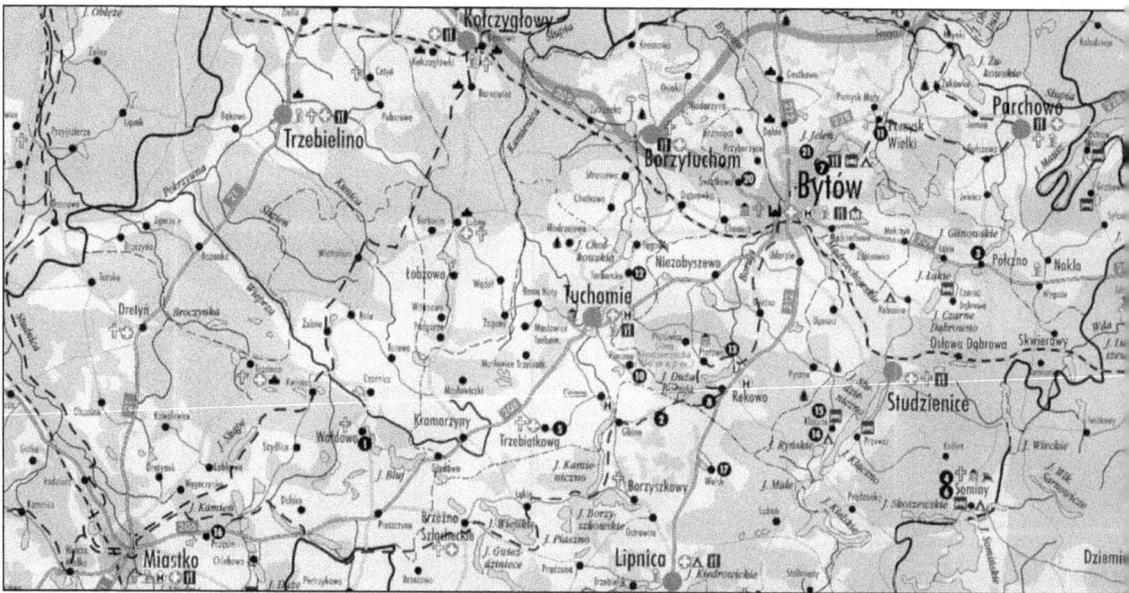

This is a very detailed map of a small part of the Kashubian region of Poland from which many Winona-area families migrated. It depicts only the center of Kashubia, the northern and southern sections having been omitted for the sake of enlargement of this area. This is a current map with spellings as found in present-day travel.

CONTENTS

ACKNOWLEDGEMENTS

The Polish Cultural Institute wishes to gratefully acknowledge the work of Ben Schultz and Father Paul Breza in choosing the photos and writing the captions and text for this book. Without them, this publication would not have been possible. Peggy McFarlin and Ron Galewski scanned and helped put together our initial proposal submission. Esther Berndt meticulously and expertly typed the text and compiled the final version, staying loyally with the project to the end! Our Arcadia editor, Ann Fugman, was extremely cheerful and helpful to us in all phases of the book, and we are grateful to her for suggesting it to us and for patiently answering all of our questions. Finally, we wish to thank all those who loaned us photographs for this book, as well as all whose photos are in this book, all who took these photos, and all who are in these photos. Without them, this book would not exist, and we are thrilled that their testimonial to the lives of the Kashubian Poles of Southeastern Minnesota will now be available to a wider public!

Drue Fergison, Ph.D.
Executive Director
Polish Cultural Institute
Winona, MN
12 May 2001

INTRODUCTION

This is an historical book searching for history! The history of the Polish people in Southeastern Minnesota has never been comprehensively or extensively preserved. There are reasons for this. The language of the Polish immigrant was not understood by the previous settlers, the Polish spoken by the Winona Poles was not well understood or accepted by other Polish people, and often the contribution of those earliest Polish settlers was neither recognized nor recorded.

So, this book is somewhat intended as a visual peek into history—many pictures with brief anecdotes and as many names as we are able to ascertain—to instigate further recognition and oral history from new sources.

WITAMY DO NAS—"Welcome to us"

Bad Polish. Not even very good English. BUT, very good Kashubian!

The majority of the Polish people of Winona came from a place in Poland called Kashubia, a small area stretching from Gdansk on the east to Bytow on the west, about 100 miles in length and 60 miles in depth. It reaches almost to the Baltic in the north, which could give cause to the commonness of light hair and blue eyes in so many of its residents and their American migrant cousins. The proximity of Sweden and the centuries of interosculation (the Swedes coming to Poland for the beautiful maidens and the Poles going to Sweden in fiscally lean times) is common history and today the explanation of the genetic blond and blue.

Besides genetics, however, that cross-national activity is also credited in the origin of that language called Kashubian. One of the most recent speculations on the language development is that frequent shipwrecks on the Baltic resulted in survivors becoming residents and thereby coloring the vocabulary extensively. Modern Poles are seen to shrug at the appearance or sound of Kashubian and say, "That's Swedish or Russian or German or something, but it's definitely not Polish!" The New Testament has been translated into Kashubian only in the last generation. That translation is now used in Polish Liturgy, but usually only on a once-monthly basis, since the youth do not understand the language. Linguists merely say that it is 500 years older than modern Polish and a very much more musical language. Kashubia was (is) a relatively obscure and tiny part of Poland, and the centuries have only made Kashubian less a dialect and more a very separate language.

This was the language brought to Winona by (our) ancestors. Remnants of that language are often heard spoken in Winona even today. That in itself is surprising when you learn of the many attempts of Polish schoolteachers, a few Polish clerics, some college professors, and many Polish visitors trying to correct, for more than a century, something that was not a mistake.

Their difficulty lay in the lack of knowledge of that tiny isolated place in which the language was spoken. That, plus the fact that Poland itself was overrun by two world wars and did not even exist in its own right during the century when (we) the Winona Poles came to these lands. We came here as Prussians! Ten years later we were Polish again—same people, same names, same addresses, only the nationality of origin was changed over here in America—and Poland itself was still gone at that time, hidden under foreign domination. But we were Polish Americans at that point. However, many remained fearful and secretive to their death, thinking that "someone" would come and get them and take them back.

"You're in a new country. Speak that language." "If you want to succeed, leave the old behind." "Polish was not allowed to be spoken in our home." All that was tied up with: "Don't you want to learn the correct way to say that?" "In school you will use the proper Polish." "You're Polish, but you don't know Polish." All the preceding are statements from Winona's oral history. None is conducive to writing or preserving history.

A pleasant surprise is the fact that the Polish spoken by the Poles of Winona stayed the same as the Kashubian spoken in Poland 150 years ago, while the Kashubian spoken in Poland was almost entirely absorbed into modern Polish. Today, the language of Kashubians is almost as lost in Poland as it is in Winona. Winonans in Poland, using the words of their great grandparents, will be greeted with the same century-old look of bewilderment until they visit (if they can find it) a city in the Kashubian area where those same few words will be respected with more deference than a passport! Instant recognition of the prodigal heir by the ancestral homeland!

Witamy do nas. It took until the start of the third millennium to correct those who attempt to correct our remnant language with "Bad Polish, but very good Kashubian!"

"Good Polish" was commonly taught in the schools. Kashubian was spoken in the homes and on the streets. Writing was taught in the schools. Could that, plus a concurrent immersion into English, be a partial explanation for the dearth of early Polish history in Winona? That plus the fact that "the English" couldn't understand any kind of Polish, let alone a Polish that wasn't even in a dictionary.

And, if the language was so difficult to understand, how could anyone ever begin to understand the customs? "Those Pollacks eat fish heads, duck blood, pig blood, and intestines, cabbage by the barrel, and things like *buchta, cziska,* and *paczka,* whatever those are . . . They even save feathers???"

Present-day Hmong immigrants could quickly understand from the Polish experience how suspicions of unknowing neighbors could quickly become requests for recipes of (now) delicacies when the only change in the ingredients is knowledge. No longer *pierzina,* now expensive down-filled quilts. Poppy seed coffeecakes, fish chowders, *kluski* noodles, endless varieties of smoked sausages and fish, egg dumplings, and potato dumplings are insatiably sought after. Migrating Poles have definitely awakened the American taste buds. How about sprinkling the homes, burning blessed candles, or putting thorns on lintels, for being unusual? Or having a statue of Christ lying dead? Polish churches have them. Poles go to church before dawn, in the morning, afternoon, evenings, and even at midnight. They pray when you come into the house and when you leave the house. They pray before taking a trip, even before taking a bath. They must have seemed too religious.

And why did they live so close to each other in Winona? They lived on half lots, in solid neighborhoods. Was it unscrupulous real estate agents selling half lots as whole lots to unknowing newcomers? Or was it foresighted brothers getting a start and then inviting others, back in Poland, to an easier start with a ready place to build next door?

Even more vexing was the problem of a Yankee attempting to spell Wojciechowski or even Przybylski, let alone Orzechowski or Wrycza? Poles are written in history, but less by name and more so as "the help," such as when the Minneowah Park, a bit south of Winona, lost its Sunday picnic activities because "the help" wanted to attend church and not work on Sundays. Can the simplest activities be recorded if the names of the involved can't be written? We know that many battlefield awards were never bestowed because the superior officer couldn't spell "Stash's"

or "Polack's" names. But is that the same reason why historical societies never list Polish homes by owners' names in their catalogues of important homes in their area? Prominent Poles were also often omitted in "Who's Who" in the county. Of course, anonymity could sometimes be a benefit when newspaper police reports often would only read: "Two Poles in a Scrape" or "Two East Enders Collared." All in all, written history of the Polish people in Southeastern Minnesota is a scarce commodity.

The pitiable part of this black hole of history is in the fact that such an innumerable member of people gave lives in service with no record whatsoever. Polish people in this area have been described as the backbone of Winona because it's a part of the anatomy that's out of sight yet supports the entire structure. Every major business in Winona—from the oldest to the newest, from the sawmills and railroad shops to the Fastenals and Ashleys—was carried on the backs of those hardworking Polish immigrants and their heirs. To make sure that these statements are not construed to perpetuate an historical false conclusion, that all the immigrants coming here were poor and uneducated, the language factor has to be added to the picture of hard workers.

Remember that the professions cannot be transported as easily as persons (both then and now). Pharmacists, nurses, teachers, and lawyers still are unable to transfer their skills without years of re-education. Re-settlement grants, job training, welfare assistance, and ESL were not even concepts in the 19th century. The immigrants, escaping as much as leaving a homeland occupied by a foreign government, had to work to survive. Common labor (such as laundresses, loggers, rail-yard snow shovelers, woodcutters, and farm hands) was the type of work most often offered. Ads such as "Poles need not apply" might not have been as discriminatory as practical— our ancestors couldn't even answer doors or telephones!

One wonders how much ability had to do with putting food on the table, whether by axe or by 12-hour stint at a washtub. Oral descriptions of Polish laborers with bowed backs from years of 12-hour days carrying mortar, or limbs crushed by logs, depict lives devoid of time or energy for the arts and humanities. Conversely, pictures of first generation immigrants in uniform, ramrod erect, holding musical instruments, from flugelhorn to symphonium, imply pre-migration education, until someone can prove that the sawmills, railroads, and factories provided on-the-job musical instruction!

Most people still can't even envision hand-shoveling all of Second Street in Winona for the railroad, let alone the 13-rail switching yard between the Chicago Northwestern Depot and the river, or better yet, hand-shoveling snowdrifts higher than locomotives off the 70 miles of rail between Winona and Waseca, Minnesota. Cutting logs in northern Wisconsin pineries for months at a time, and sawing and splitting cordwood on Wisconsin farms for sale to Winona stoves (only after a sleigh-load ride across the frozen Mississippi) were all livelihoods, literally, not careers. Polish immigrants in the 1990s have had to give up careers in law and psychology because of that same financial inability to retrain or re-license to American requirements. Looking for work may imply poverty, but not necessarily a lack of education. Just being a laborer merely implies the same.

So, the jobs as well as the language, customs, and Yankee inability to spell all contributed to this lack of written history. Anonymous jobs employ masses of people who remain unknown; all the while their labor and production propel their managers and owners to ever greater renown.

This book is an attempt to reveal some of this history that is already known and also to instigate further revelation and research before the opportunity and information are lost forever. So, *Witamy Do Nas*—Welcome to Us!

An outline of Poland is seen here. The darkened area denotes the Kashubian area, about 100-miles long and 60-miles wide.

One

In the Beginning

Seen here is a Kashubian language map of the area being studied. Note the *Gryf* in the corner of the map. Though pictured with wings as a bird that could fly anywhere, it has four claws to show its fearsome strength, like that of a lion. Note also the crown on its head, which symbolizes dominion still present in Poland today.

This is a recent photograph of Old Town, Gdansk.

This church is located in Ugoszcz. It is a good example of Kashubian architecture: masonry and wood.

Pictured here is a beehive—believe it or not—found in the Bytow Museum. It serves as an example of folk art.

This side altar can be found in the
Ugoszcz church. Note the *Little Christ
Sleeping* statue above the tabernacle. That
statue is also seen in Winona homes.

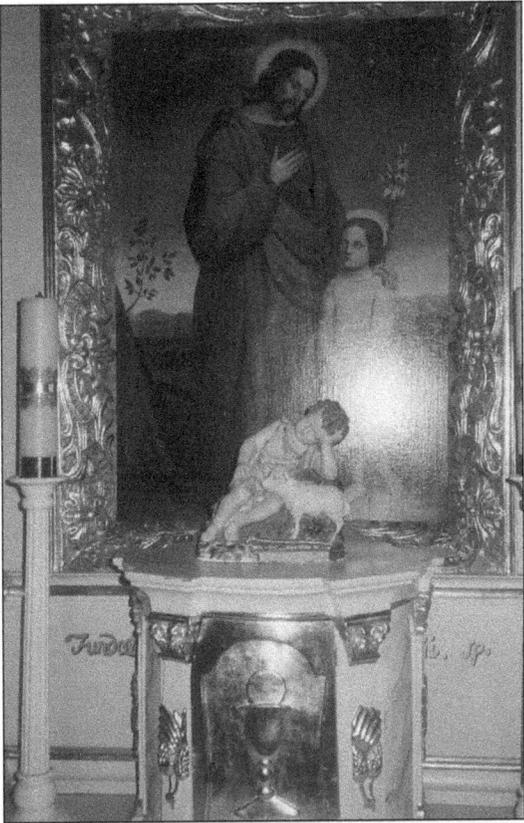

The Gothic Teutonic Knights castle in
Bytow dates to the 14th century.

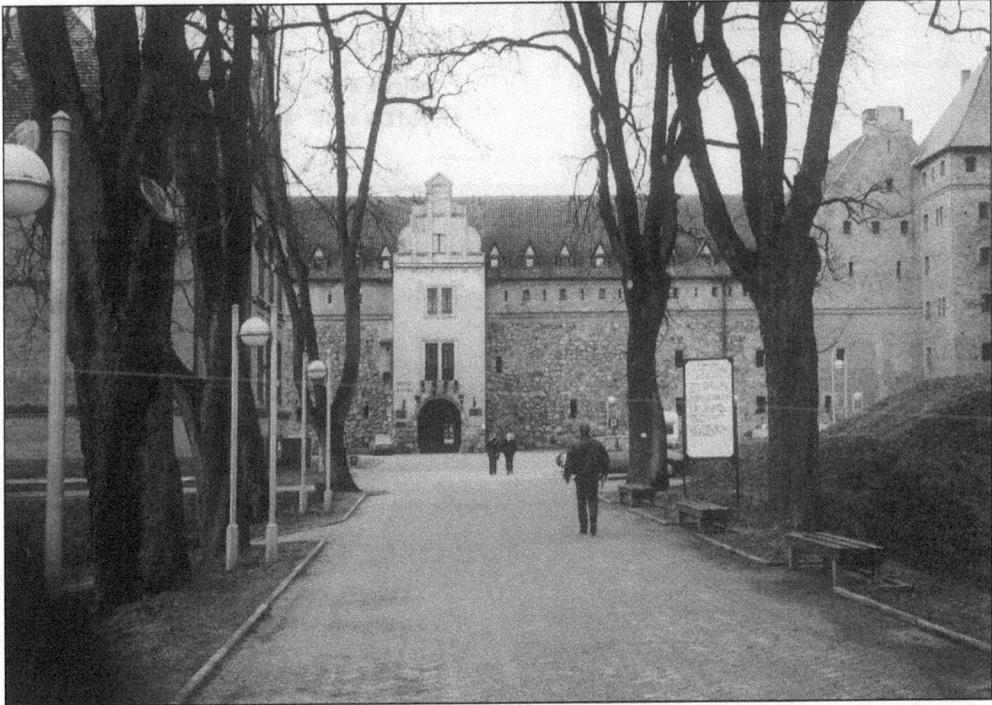

This is a railroad trestle in Bytow.

Above: Jacob Czyrson (Cierzan), born July 20, 1841, was issued a passport by the Kingdom of Prussia. He sailed from the port of Bremen to North America in 1859.

Right: The English translation of Jacob Czyrson's passport.

Royal Prussian States
Overseas Passport

Data on Passholders	For the	Traveling
1. Place of birth: Studzienice	Son of a self-employed	from here
2. Place of residence: Osława Dąbrowa	father	
3. Year and date of birth: 20 July 1841	Joseph Jacob	via Bremen
4. Height: illegible	von Czyrson	
5. Hair: light blond	from Osława Dąbrowa	to North America
6. Eyebrows: blond		
7. Eyes: blue		
8. Nose:		
} large and prominent		
9. Mouth:		
10.Beard: none		
11.Complexion: illegible		
12.Stature: small		
13.Special Features: illegible	Reason for traveling:	This passport is
	for emigration	valid for travel to
		North America
Signature of the passport holder		from 24 May 1859
		onward
xxx (signed for v. Czyrson)		

All civil and military authorities shall be advised that the bearer of this document which
has been issued by
(signature illegible)
is legitimately, without suspicion free and unhindered to travel, and to return,
and also in emergency, he is entitled to protection and assistance.

Given at Coeslin
} 7 June 1859
Koszalin

Stamp – 5 Sgr.
Tax – 10 Sgr.

Seen here is St. John's Gospel, 1:1–12, in Kashubian. Note especially verses 9, 11, and 12 to realize disparate vocabulary, spelling, and word arrangement. Most people had this part of the Gospel memorized, and it became easy to see and hear that one or the other language would appear to be in error if both were considered Polish.

EWANGELIA
WEDŁUG ŚW. JANA

1 Na początku było Słowo, a Słowo było u Boga, a Bogiem było Słowo. ² Ono było na początku u Boga. ³ Wszystko przez nie powstało, a bez niego nic nie powstało, co powstało. ⁴ W nim było życie, a życie było światłością ludzi. ⁵ A światłość świeci w ciemności, lecz ciemność jej nie przemogła.
⁶ Wystąpił człowiek, posłany od Boga, który nazywał się Jan. ⁷ Ten przyszedł na świadectwo, aby zaświadczyć o światłości, by wszyscy przezeń uwierzyli. ⁸ Nie był on światłością, lecz miał zaświadczyć o światłości. ⁹ Prawdziwa światłość, która oświeca każdego człowieka, przyszła na świat.
¹⁰ Na świecie był i świat przezeń powstał, lecz świat go nie poznał. ¹¹ Do swej własności przyszedł, ale swoi go nie przyjęli.
¹² Tym zaś, którzy go przyjęli, dał prawo stać się dziećmi Bożymi

Pictured on the right is part of the Gospel according to St. John, written in standard Polish. Compare it with the Kashubian example, below.

EWANIELËJÔ WEDLE SW. JANA

DZEJANIÉ JEZËSA CHRISTUSA JAKO SŁOWA, WIDU I ŻÉCÔ

O SŁOWIE

Prolog

1¹ Na zôczątku bëło Słowo*
a Słowo bëło u Boga*,
i Bogę bëło Słowo.
² Ono bëło na zôczątku u Boga.
³ Wszëtko przez Nie sę stało,
a bez Niego nic sę nie stało,
co sę stało*.
⁴ W Nim bëło żécé*,
a żécé bëło widę* lëdzy,
⁵ a wid swiécy o cemnicą,
a cemnica go nie objimnęła.
⁶ Zjawił sę człowiek posłóny przez Boga —
miono jego bëło Jan*.
⁷ Prżëszedł on na swiôdczenié,
żebë zaswiadczëc o widze,

żebë wszëtcë przez niego uwierzëlë.
⁸ Nie bél on widę,
le [bél posłóny], żebë zaswiadczëc o widze.
⁹ Bél wid prôwdzëwi,
co obswiecywô kożdégo człowieka,
cziej prżëchôdô na swiat*.
¹⁰ Na swiece bëło [Słowo],
a swiat przez Nie sę stôl,
ale swiat* Go nie poznôl*.
¹¹ Prżëszło do swégo miectwa,
a swoji Go nie prżëjęlë.
¹² Równak tim wszëtczim, co Je prżëjęlë,
dało moc, żebë sę stelë Bożima dzecama*,
tima, co wierzą w Jego miono —

15

This baptism certificate of Thomas Walczak is dated December 10, 1865.

John Cichanowski, formerly a Prussian citizen, filed a certificate of intent to become an American citizen on September 14, 1875.

This certificate of naturalization for Thomas Walczak is dated December 23, 1896.

This farm in Dodge, Wisconsin, typifies where Kashubian Poles settled in Buffalo and Trempealeau counties across the Mississippi River in Wisconsin as early as 1859. The parish church of the Sacred Heart and St. Wenceslaus in Pine Creek, Wisconsin, accommodated parishioners of either Polish or Bohemian origin. Pehler, Bronk, Eichman, Walenski, and Bambenek families came to Winona in 1856. The Libera, Losinski, Wejer, Wnuk, Zabinski, Pelowski, Kaldunski, Reszka, and Literski families followed suit three years later. In 1860, Bohemian families also settled in the area.

Derdowski poem
Forever in Winona
Our pastor must remain
As a beautiful voice in the pulpit
How well groomed in his appearance
 At once the whole parish likes him
 They don't deny him money or bread.
The Kashubians greet each other by saying
 "This is the priest who we need."
He with a pen of the Evangelist
In the name of Lord Jesus.
 Page 32 in *Dzialansci Literary & ------------H*

 Goodbye, bye, bye,
It's necessary to travel the country
From West to East,
Where the Polish people are
With Polish blood in their veins.
And you can hear the Polish singing,
Where there are Polish schools,
And people want to read.
 Page 43 in *Dziatansci Literary & -------------H*

Seen here are samples of Hieronim Derdowski's work as Alice (Pehler) Breza translated it. Those who speak present-day Polish will recognize the difficulty of translating Kashubian Polish into English.

Alice learned to read and write in Polish from her grandmother Mary (Peplinski) (Bojan) Jaszdsewski. Mary had to have little Alice write letters to the homeland for her and so the education in the language took place. These might be the only extant translations into English of these two small poems.

17

Seen here is an Alien Certificate of Registration. Mary Cierzan Wieczorek came to America in 1880 at the age of six. She married Jacob Wieczorek in 1894. Why the need for this certificate?

This final certificate of naturalization of Laurence Radomski is dated October 10, 1896. Note the line "He renounced all allegiance and fidelity to every foreign prince, potentate, state and sovereignty whatever, and more particularly to the reigning Sovereign of the Kingdom of Prussia."

Front and High Forest

Swimming off the
Sand bars
Then searching the
River to find
A stone for
Duck on a rock
Orange birds flew
Thistles grew
While all the
Kids played
Shinny on you
Growing out of
Their dreams
Golden grapes hang
Overhead
Gooney laughs to greet
A lumber pile holds the
Promise of Winter
Warmth
A worm bed
Behind the shed
Green sweaters folded
In boxes
Quilts on the line
When the weather
Is fine
They all leave
For years
They roam
Then return home
Without fear
To leave a mark
Saying
I was here

Poem by Winonan, Audre Kluzik.

Two

NOTANDA

The majority of Polish people in Southeastern Minnesota came from a relatively small area of north-central Poland known as Kashubia.

The land of emigration in 1855 to 1918 was under Prussian domination.

Their immigration started in 1855 and reached its crescendo in the 1870s with boomlets and trickles continuing to date, often associated with war, insurrection, and/or repression.

The first Polish settlement in Winona was at the river between Laird and Vine Streets, called Warsaw, later styled Eskimo Avenue, and currently occupied by the Winona Yacht Club.

Winona's Polish immigrants were all bilingual, since German was taught in the Prussian schools and they had to attend school until 14—a legacy of the Kulturkampf process promulgated by the Iron Chancellor Otto von Bismarck. Priests taught Polish (if they hadn't been "removed").

The Kashubs are not just localized in Southeastern Minnesota. Their settlement includes the cities of Fountain City, Pine Creek, Dodge, and Trempealeau, Wisconsin. Residence often included two or three of these cities in a lifetime, plus several forays north and west in homesteading attempts.

The Winona Kashubian settlement is reputed, in Poland, to be the largest in the United States. Other settlements are found in Stevens Point, Berlin, and Polonia, Wisconsin, along with Renfrew, Canada.

Winona Poles have served in the military for the United States—from the Civil War to Saudi Arabia—since their arrival.

Poland was known in Europe for lumber, sawmills, and lumberjacks. Forests were vital for not just lumber, but also for berries, mushrooms, honey, game, and fur-bearing animals. However, hunting was mostly forbidden by the big landowners, and Polish poachers got to be known as the best in Europe.

Fishing was also essential and appealing to all Poles. They would net fish and dry or smoke them for winter. Some of the indoor smoking facilities are preserved yet in Poland, with the front of the smoker used for cooking and to heat the smaller old homes.

In Winona, employment was found in the lumber mills, flour mills, and breweries, in the Chicago and Northwestern Railroad shops in the West End, as clerks, domestics, and as factory laborers. In nearby Wisconsin, newcomers took up farming.

There were five sawmills in Winona: Empire, Laird-Norton, Winona Lumber Co., Youmans, and Schroth and Ahrens. (Two thousand people were involved in that industry at the turn of the century—1200 of them were Polish.)

A sawmill worker named Kulas got caught in the belts of the mill, which caused 72 fractures. George Tweedy (father of Bob) made a bed of cement and bricks and mud and laid him in it with a bedpan underneath. The man survived!

Schroth and Ahrens was number one in woodwork in the whole world!

There were 2 to 3 acres of logs in a log raft.

Pay was $32 a month for a 12-hour day, 80-hour week in Winona sawmills.

The sawmills had taken the usable timber within reach of their industry by about 1910. This apparently gave way to secondary migrations to areas further west, often as homesteading attempts. Cities such as Jamestown, Scranton, and Beach in North Dakota, as well as Wibaux and St. Philip in Montana, all felt the effects of those secondary waves. The later the migration, the farther west the homesteads had to be made. The first generation of the 20th century witnessed many Kashubian families being torn apart a second time.

There are two Polish parishes in Winona: St. Stanislaus in the east and St. Casimir in the west. St. Stanislaus served all the Polish people in Winona since its inception in 1871, until St. Casimir's was started in 1905 as a daughter or mission parish of St. Stan's.

Until the Winonans had their own church with a Polish-speaking pastor, they worshiped at St. Thomas Church, the Irish parish established in 1856, or at St. Joseph's, the German church built in 1862. Understandably, the homilies in the English language presented a problem in both places, though following the Mass presented no difficulty, since everyone was familiar with the Latin format from the old country.

As the ingress of Polish immigrants increased in the East End, it became clear that these folks needed a church of their own. Father Aloysius Plut, pastor of St. Joseph's Church, the closest to the Fourth Ward where the majority of Poles lived, encouraged his Polish parishioners to form their own parish. With the bishop's permission, a committee was organized in April 1871 to do just that, and named the new parish for St. Stanislaus Kostka, a Polish Jesuit. In 1872, a small frame building was erected on the corner of East Fourth and Carimona Streets. Not many years later, it had to be enlarged. By 1893 the parish had grown considerably so that it was again necessary to expand.

The present church of St. Stanislaus Kostka was erected in 1894–1895. This Romanesque structure replaced the much smaller building dating from the founding of the parish in 1871. As mentioned, the earlier frame structure was enlarged to accommodate the increasing numbers of immigrants into the parish, a process reaching its peak in the 1880s and 1890s.

There were daughter cities even with the first migration. Whether it was lack of job opportunity or lack of homesteading opportunity has not been documented, but we do know that Browerville and Perham, Minnesota, have Polish people with relatives in Winona—also Wilno and Warsaw, in North Dakota. Warsaw states that it owes its existence to Winona. A visit to St. Stanislaus Church in Warsaw, which was built to hold 1200 people, St. Stanislaus school, a two-story red brick structure (now closed), and the parish cemetery—with hundreds of Winona names—gives instant credibility to the statement. This wave of migration took place before the 20th century had begun. The ties are now very weak, but ancestral mining expeditions still are being undertaken.

Winona, in spite of its small size, was also on the Polish map nationally, in part due to the newspaper *Wiarus*, published in Winona by noted Kashubian poet Hieronim Derdowski—and widely distributed in both North and South America.

Kurjer Winonski was a single-issue paper published previous to 1886. *Kurier Bytowski* is the name of the current paper issued in Bytow, Poland—the town from which the majority of Winona's Poles hailed.

A quotation from Derdowski reads: "Many of the Winona Poles did not learn their Polish language well until they came to live here in Winona," referring to the literary Polish used in his paper.

Today, after the long-ago German, and most recent Russian occupations, Poles are tri-lingual in Polish, Russian, and German. Quad- and quint-, if you include Kashubian and now the commerce-driven English.

Polish immigrants were willing to work hard, and the caliber of their work was excellent. They were the lowest paid industrial workers in the region, but they knew how to conduct their households economically, and how to accumulate savings in spite of seasonal unemployment. These qualities brought respect in the community.

Three

EARLIEST ACTIVITIES

These two Civil War hats were owned by Anthony Pehler. He was born on June 13, 1843, in Bytow, and arrived in Quebec on July 8, 1859. He applied for citizenship in Winona on November 5, 1867. He died in May 1928.

Obituary

ANTHONY PEHLER, SURVIVOR OF MANY CIVIL WAR BATTLES, DIES HERE AT AGE OF 84; WILL BE BURIED TUESDAY.

Had Adventurous Life Came to America on Sailing Vessel, Enlisted Twice in Union Army, Started Out in Prairie Schooner.

Anthony Pehler, 84-year-old Winona pioneer and veteran of 32 battles of the Civil War, died at 2 a.m. today at his home, 114 East Wabasha Street. He had been confined to his bed for four months, but his condition became more serious Sunday. His daughters, Miss Ruth Pehler, and Miss Katherine Pehler, retired for a short nap and awoke to find him dead.

Mr. Pehler, who had a long and diverting life, was born June 13, 1843, in Buetow, Germany, the son of a wealthy landlord, and came to America in a sailing vessel when a boy of 15, landing at Quebec. He landed in Winona after a land and water journey July 8, 1859, and although he left Winona several times for short periods, Mr. Pehler made his home here most of the time.

He worked on a farm near Witoka and went to Dubuque, Iowa, where he was employed for two years before the outbreak of the Civil War. He went to St. Louis to enlist and joined Company I, 17th Missouri infantry Volunteers, which was already organized. He enlisted for three years and entered actual service at once. The first important engagement he figured in was at Pea Ridge, Missouri.

IN MANY BATTLES

He participated in both the first and second attacks at Vicksburg, the battle of Lookout Mountain, Missionary Ridge, Chattanooga and last at Atlanta, Ga. There his three years expired and he was discharged to return to St. Louis. He was not wounded in any of the battles or skirmishes although he was on the firing line and fighting throughout the war. One bullet passed through his hat and took a portion of his hair but drew no blood.

Mustered out at St. Louis, Mr. Pehler boared [boarded] a steamer and returned to Winona, arriving here in November 1864. He remained here during the winter, but on Feb. 15, 1865, he went to Rochester to help Olmsted County bring up its quota and re-enlisted, this time with Company K, first Minnesota Heavy Artillery. They proceeded south to Chattanooga and were stationed there in garrison duty until the close of the war. He was mustered out at Nashville, Tennessee, and again returned to Winona.

The following spring, June 9, 1866, Mr. Pehler married Miss Mary Niemczyk, Winona at Fountain City, and went on a honeymoon trip to Trempealeau behind an ox-team. They resided in St. Louis a short time after their marriage and returned to Winona.

Mr. Pehler secured work as a pressman and at that work was employed for eight years. He went to Pine Creek, Wisconsin, and conducted a general store and saloon. Following the advice of Horace Greeley, he decided to cross the plains to the far west. With his wife and children he went to Owatonna and settled.

EQUIPPED PRAIRIE SCHOONER

Here he equipped a prairie schooner and started across the plains alone. He proceeded to Pierre, South Dakota, where he was overwhelmed by the pleading of people returning from the land of promise, gaunt and worn from their journey. Taking their advice he returned to Sioux Falls, South Dakota, where his wife and family met him. He secured a position as pressman for a daily paper and remained for four years.

Returning to Winona, he was given a position as night watchman at the Winona Mill company's plant. He remained there two years and opened a job printing office, placing his son in charge until he resigned and also became active in the office. There he remained nine years and retired.

During his employment at the Winona mill, Mr. Pehler erected a residence at 323 East Second Street, here he resided until two years ago.

FUNERAL TUESDAY

Mr. Pehler is survived by seven children: George, Des Moines; Alex, Quincy, Ill.; Mrs. Arthur Smith, Montgomery, Ala.; Mrs. William Gardiner, Sheldom [Sheldon], Iowa; Miss Ida Pehler, Honolulu, Hawaii, and the Misses Katherine and Ruth at home.

Private funeral services will be held at 2:30 p.m. Tuesday at the Breitlow funeral parlors, and burial will be in St. Mary's cemetery. Friends are requested not to send flowers.

(From newsletter Lister.)

William Hering was an early East End Winona businessman. He had a tavern on the northeast corner of Second and Hamilton. He came to Quebec on the sailing vessel *Liebig* in 1868 at age 30 with his wife Elizabeth (age 24).

This passport and military travel orders was for Franz Skuczynski, born November 13, 1849. Is it a Prussian Army Pass? It allows (orders) travel to various places, including Paris, in 1870.

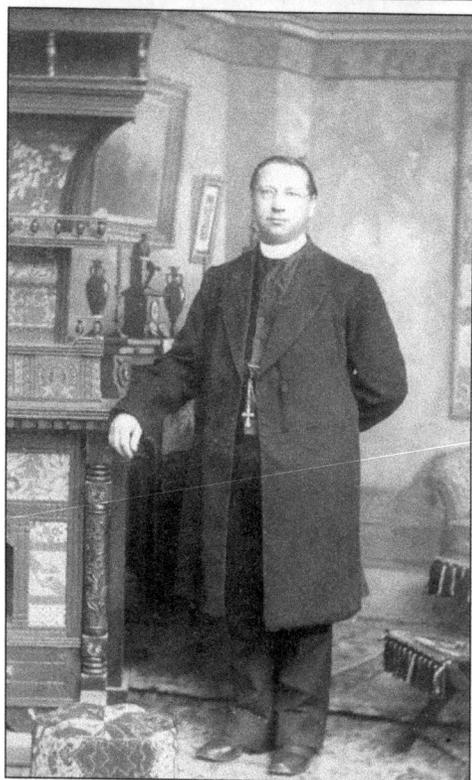

St. Stanislaus Kostka Society was
founded in 1870. Pictured, from right to
left, are as follows: (front row) Thomas
Bloch, a policeman and grandfather
of Rev. Lawrence Ginther, 13th from
right is Julius Betka; (second row) #13
is Tony Wilma; (third row) #7 is John J.
Pehler, #27 is Andrew Jezewski; (top row)
second from last on left is Martin Koscielski,
grandfather of Dorothy Walch.

Rev. Romuald Byzewski, O.F.M.,
was the pastor of St. Stanislaus
Church from 1875 to 1890.

L.Sztefanski; F.Reszka; M.Kulas; F.Maliszewski; T.Milkowski; M.?......inski

At the outbreak of the Spanish-American War in 1898, the whole of Company E, Minnesota National Guard, was composed of Winona County men. Among them, Jacob Michalowski was a first lieutenant, and Leonard J. Bruski a second lieutenant. The company was mustered into service in May of that year and mustered out the following fall.

Other members of the unit were Sgt. Joseph Czaplewski; Cpls. Max Buczynski and Vincent Kropidlowski; Pfc. Teofil Milkowski; and Pvts. Mike Stefanski, Frank Reszka, Michael Kulas, Frank Maliszewski, John Wieczorek, Joseph Gromowski, John Boland, Paul Grulkowski, Harry Rackow, Leo Reszka, Mike Szablewski, Anton Gallas, Frank Szarmach, John Bernac, Anton Zabrocki, Joseph Grajczyk, Reinhold Eichendorf, and August Czapiewski.

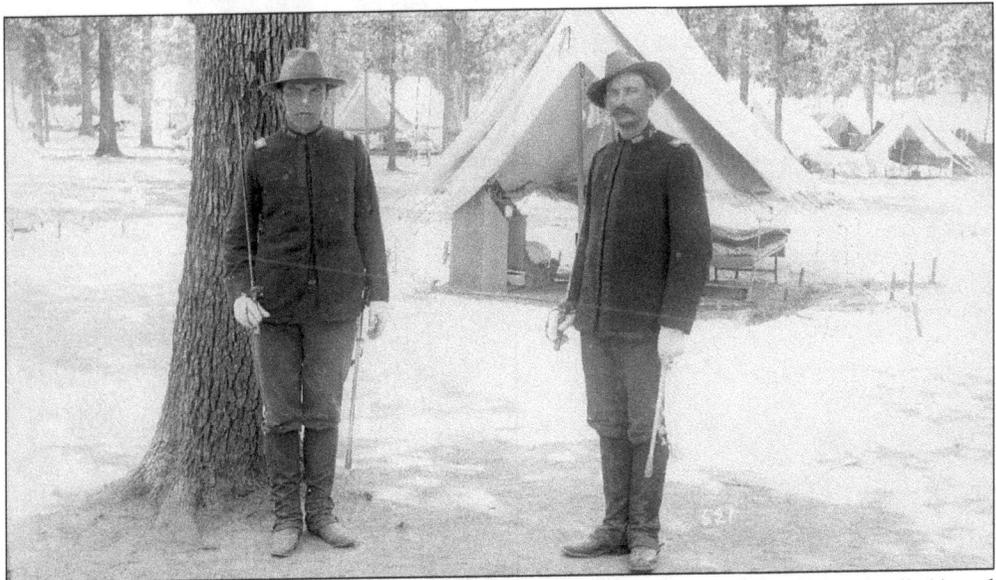

These Spanish-American War veterans are identified as First Lt. Jacob Michalowski (left) and Second Lt. Leonard Bruski.

25

Pictured here is Spanish-American War Cpl. John Milkowski.

THE EARLY CHURCH OF ST. STANISLAUS

The Rev. Alois Piat

The Rev. Joseph Juszkiewicz

Seen here is the early church of St. Stanislaus.

This quote was written on the back of the photograph in Polish: "This is Grandpa Breza's photograph that he had to have when he left the boundary line."

Certificate ✝ of Baptism

I Hereby Certify, that _Francisca J._

Son/Daughter of _William Hering_ and _Elizabeth Lilla_

was born on the _eighteenth_ day of _June, 1872_ and was

Baptized on _June 22. 1872_ at _St. Joseph's church, Winona_

Stanislaus Wira ⎫ Sponsors.

Ludovica Wira ⎭ Signed _John Meier_

Winona, June 10. 19_19._

Rector.

Diederich-Schaefer Co., Milwaukee

This Baptismal certificate was for Frances Hering, born on June 18, 1872. She was baptized at St. Joseph's Church four days later. There was no Polish parish functioning at this time and most Poles joined this parish, as the certificate helps to illustrate.

This serves as an example of communication from "home." A letter addressed to Mrs. August Hering of 976 East King Street, Winona, signed by Wanda Bruska of Chojnice, Pomorze, Poland. Note the blessing in the greeting and closing; the reference to war with enemies driven to Russia and Prussia, and the reminder of 40 years passing since Mrs. Hering left there. This letter was dated 1921.

This is the English translation of the text above.

My dear Sister and relatives,

First just a few lines to say " Hello " in the name of Jesus Christ. We thank God that we are healthy and hope the same from you. - Dear Sister, w e have just received your address from Sister Ambietry so we can write a few words to you. - Dear Sister, it has been 40 years, since you left for the United States. You should remember, that you still have a brother in Poland by the name of Andreja Bruskiego. - Listen dear sister, remember there are still 4 brothers: Andrej, August, Tomasz, Aloyzi and a youngest sister Kataryna They all had a very hard time through the war which lasted 4 years. My brother and his friend " Ourich " went to France. - Dear Sister, In our country there was war too, so our enemies were driven out of our country to Russia and Prussia . - Dear Sister, I am writing and telling you that I am married already for 20 years, my wife's maiden name was " Kosobut " and she was born in " Wotolochow ". She has a sister " Anna " We are 12 in our family, they are : Jozefa, Jozeph, Maksmiljan, Jan, Brona, Alfons, Wanda, Brunon, Anna, Eufemja, Dorota, and me and my wife. From 1906 till 1929 we rented 36 morg land, now we bought our own a small farmhouse with 8 morg of land. We paid 4 Złoty for one morg of land. - Dear Sister, My brother in law asked how you all are and how your family is, we hope that all are healty. We had a very bad winter from Dec. till March. Now spring is coming, and the snow is melting. Dear Sister, Rozalio is also asking if you and your family are healty Great them all from us from our heart and tell them they should write to us too. - Here in Poland many people have died, there is a funeral almost evey day. - Dear Sister and brother in law I am looking forward to receive mail from the United States so we can communicate through the letters. My Uncle wrote that Wanda Corka, who stays at my fathers place, will receive her fist communion in September. My mother and Father write to us in German, but we could not read it.
I am writing this letter, which will reach you through Mountains, Woods and Sea. God bless you all and greeting in the name of Jesus Christ. One more greeting to you from my heart and please write soon.

28

This booklet is entitled "Prophecies about Poland and other countries where Poles lived. Also stories about the Catholic Church." It was published by Hieronim Derdowski in 1883.

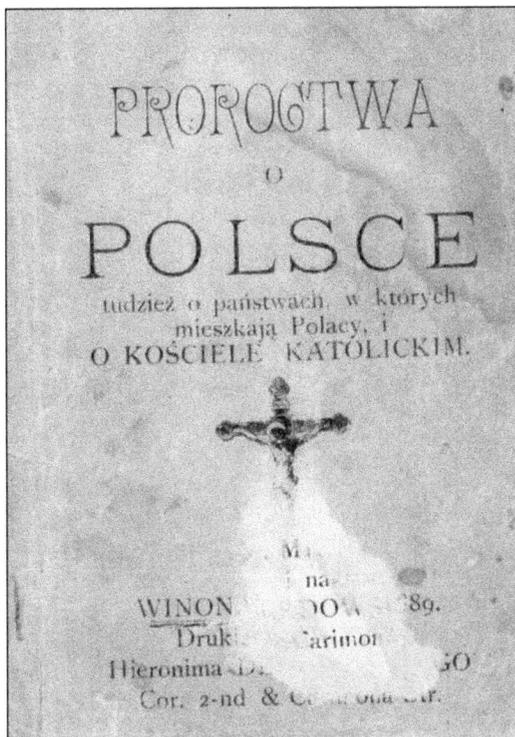

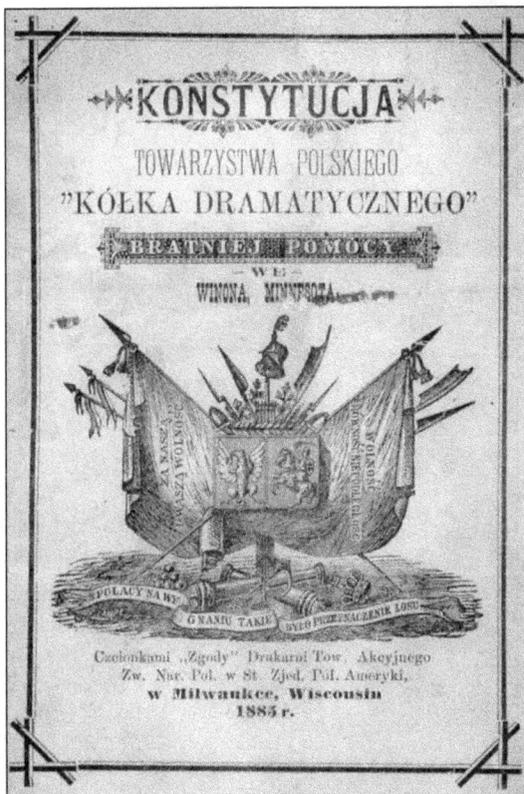

Pictured here is the constitution of the Polish Dramatic Society, St. Stanislaus Parish, 1885.

The officers were: Albert Libera, Paul Libera, Jan Cichanowski, Robert Zaborowski, Wincenty Kupferschmidt, Josef Jazdzewski, Marcin Weier, T.M. Cysewski, J.A. Zaborowski, Marcin Trawicki, Michal Weier, and Jozef Walinski.

(handwritten) (77) Jakob Losinski

KONSTYTUCYA

USTAWY I REGULY PARLAMENTARNE

Towarzystwa

Bratniej Pomocy

POD WEZWANIEM

Św. Stanisława Kostki

— w —

Winona, MINNESOTA.

WINONA, MINN.
Czcionkami Drukarni WIARUSA.
1897.

Pictured here is the constitution of the Fraternal Assistance Society of the Church of St. Stanislaus Kostka, in 1897. The officers were Julius Betka, Jan Zbilicki, Jan Anglewicz, Anton Cierzan, Stanislaus Czaplewski, Jan Jereczek, and Jan Grochrowski.

KONSTYTUCYA

TOWARZYSTWA

Młodzieńców św. Józefa

Założone dnia 21go Czerwca 1898 roku,
w Parafii Św. Stanisława Kostki

— w —

WINONIE, MINN.

Konstytucya poprawiona 7go Czerwca 1911 roku.
Potwierdzona przez
Przew. Ks. Proboszcza J. Pacholskiego.

DRUKIEM J. DERDOWSKIEJ W WINONIE, MINN.
1912

This is the constitution of the St. Joseph Society, founded in 1898. It was printed and published by Hieronim Derdowski in 1912.

This receipt booklet shows August Hering's financial support for church, school, cemetery, and general repairs between 1895 and 1932.

Seen here is a proof of Easter Confession. Catholics are required to make a confession at least once a year.

The church and rectory of St. Casimir, located on West Broadway, Winona, was founded in 1905 as an offshoot of St. Stanislaus.

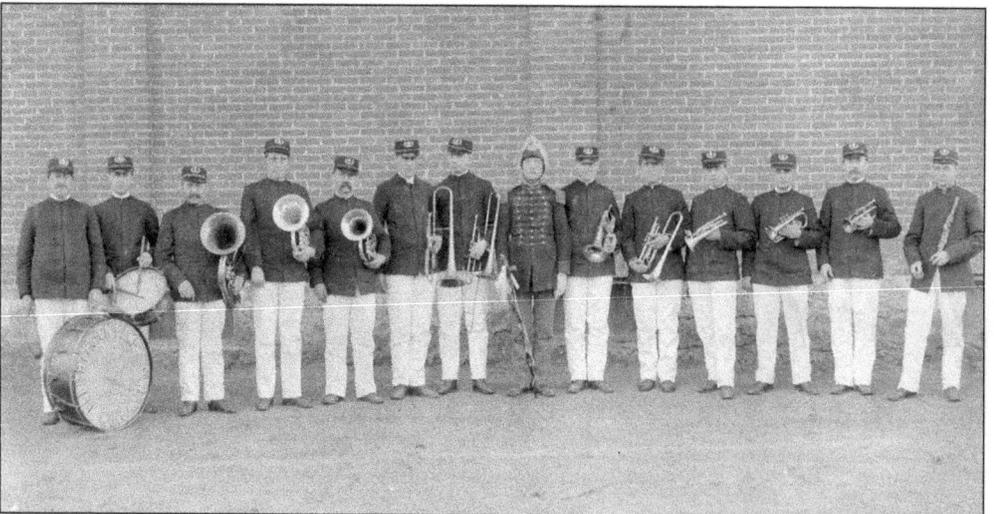

One of the men's organizations in the parish of St. Stanislaus Kostka was the Polish Legion Band. Pictured, from left to right, are as follows: F.L. Cierzan, Gus Ceslik, five unidentified men, Clarence Maliszewski, unidentified, "Blood" Osowski, and Max Cieminski.

Members of the Polish Legion take time out from rehearsals. Frank L. Cierzan sits first at left.

A well-furnished kitchen with a wood stove was standard equipment in Winona homes. Clearly, the two ladies in their well-turned-out dresses have started preparations for the meal. The site is St. Stan's Rectory.

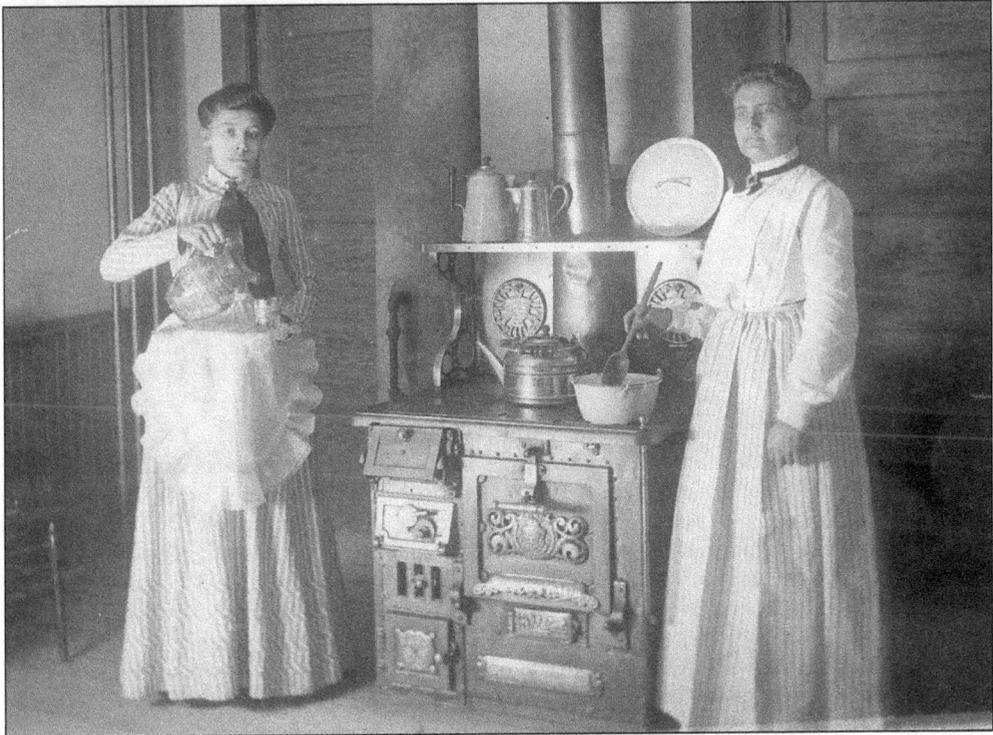

Winona's Polish-American presence in World War I ended, as did the war itself, on November 11, 1918. The list of casualties from both parishes included the following: Pfc. George Libera, Pvt. Frank Czapiewski, Pvt. Leo Grochowski, Pvt. Peter J. Apka, Pvt. Michael Jereczek, Pvt. Stanislaus Palubicki, Pvt. Teofil Prondzinski, Pvt. Romuald J. Ritter, Pvt. Albert Stanek, Pvt. Frank Starzecki, Pvt. Joseph V. Stoltman, and Seaman Leon J. Wetzel, after whom Winona's American Legion Post #9 was named. He was the first local casualty of the war.

Pvt. Lambert B. Cysewski was awarded the *Croix de Guerre* by the French government.

In 1918, this photograph was taken of the American Red Cross Ladies organization of the church of St. Casimir. Pictured, from left to right, are as follows: (front row) Mrs. I.J. (Anna) Szuminski, Gertrude Drazkowski, Mary Zientek, Mrs. Walter (Mary) Losinski, Mrs. John (Anna) Kowalewski, Mrs. Stella Hanley, Mrs. Helen Stroinski, Mrs. John (Cecelia) Piechowiak, Mrs. Jereczek, Mrs. J. Kolla, and Mrs. S. Kurkowski; (top row) Mrs. Anna Franckowiak, Mrs. John Newman, Mrs. Elizabeth Bruggerman, Mrs. Lucas Andrejewski, Mrs. Michael (Julia) Libera, Mrs. Dominick Drazkowski, Mrs. Joseph (Frances) Grajczyk, Mrs. E. Newman, Rose Bratek, Mrs. Cecelia Gappa, Mrs. J. Chuck, Mrs. Mary Losinski, and Mrs. T. Jozwiak.

The ladies of St. Stanislaus Parish did their share to support American troops in World War I. Pictured, from left to right, are as follows: (first row) Florence Kustelski (Mrs. Al Bambenek), Isabelle (Mrs. Frank) Cierzan, Maggie Mlynczak Peterson, Sally Sieracki (Mrs. Ray Krier), Helen Sieracki, and Ceil Owecke; (second row) Mrs. Slagowski, Mrs. Cieminski (Msgr. Joseph Cieminski's mother), Mary (Mrs. John) Wieczorek, Mary (Mrs. Leonard) Bruski the chairwoman, Celia (Mrs. Joseph Goven), Mary Sieracki Kustelski (Florence's mother), and Angela Bruski; (top row) Mary Weir (Hubert's mother), Mrs. Kuklinski, Helen Cichanowski (Mrs. Faber), Sarah Weir, Mrs. Lawrence Jaszewski, Ann (Mrs. Joseph) Palbicki, and Miss Gertrude Sieracki.

Joe Bambenek, seen here, was a World War I veteran.

Stance Briza was also a World War I veteran.

The back of this photo reads: "Gregozewski, World War I."

Cpl. Vincent Breza was a World War I veteran.

Three pictures of Bubbie Ruhnke from World War I were sent back to Winona. The quote on the back of the photo above reads: "How is this for boxing? Com down und I will learn you." The photo below says, "How's this for washing?"

Birdseye View CAMP Cody Deming N. Mex.

This postcard, postmarked December 19, 1917, was received by Ted Bambenek, 767 East Fifth Street, Winona, from a friend at Camp Cody, New Mexico. The message reads: "Hello Ted. Feel fine. Rec'd the snuff. Ain't got time to write today but will write you a letter later. Ted, you will see Coxy Rostanka in Winona in a few days. He is going to get a discharge. He's got a touch of the con. Merry Xmas and a Happy New Year, Ted. Your friend, Peg."

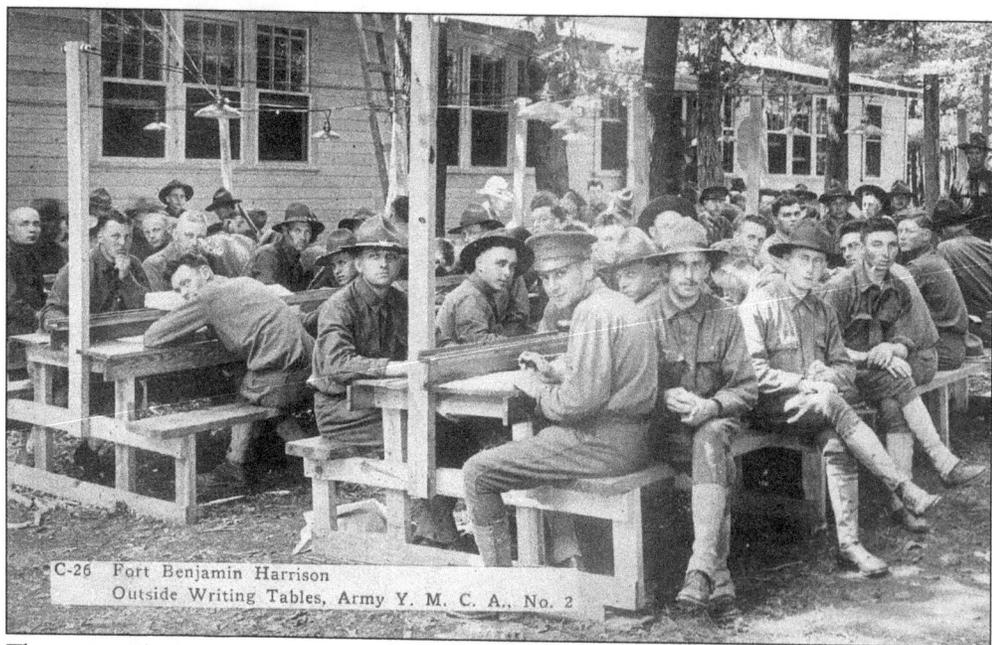

C-26 Fort Benjamin Harrison
Outside Writing Tables, Army Y. M. C. A., No. 2

This postcard was sent from Fort Benjamin Harrison. It displays outside writing tables. It is signed on the back by "Ted" (Bambenek?).

38

Four

EARLY SETTLEMENT

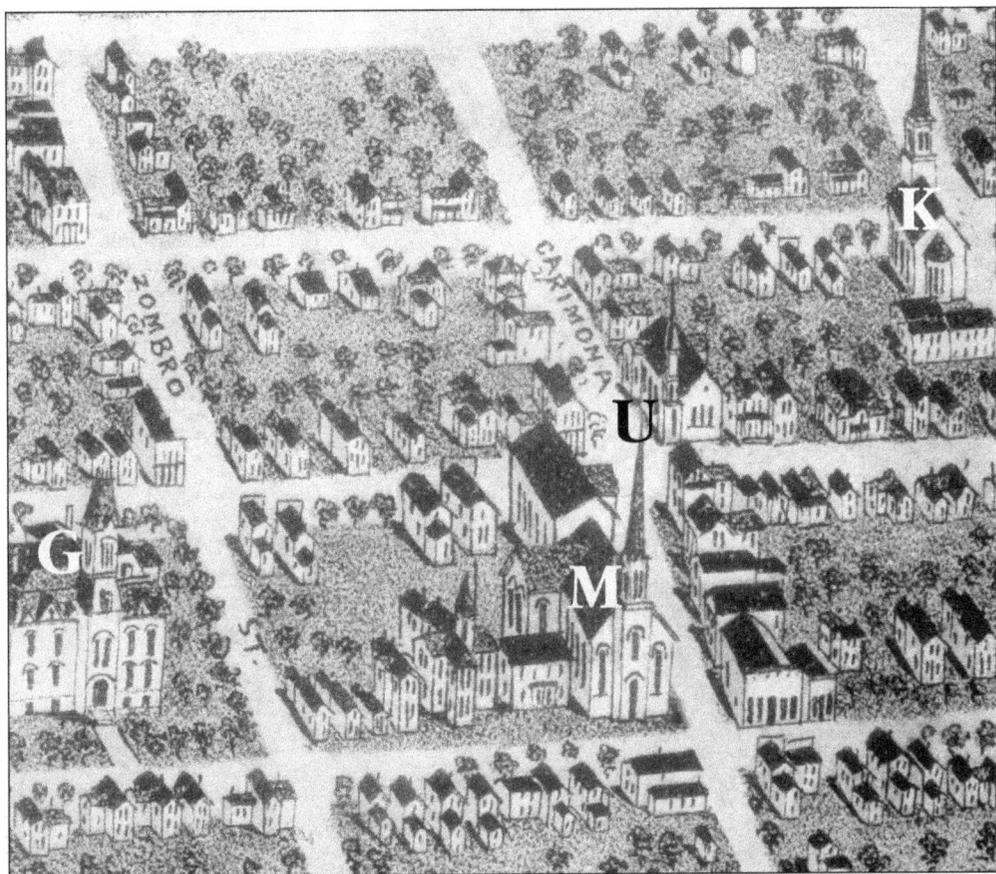

This pencil sketch of St. Stanislaus Church marks the area between Zumbro and Carimona Streets in Winona. The church building marked with an "M" was the original St. Stan's. St. John's Church is shown one diagonal block away with the letter "K." The church between St. John's and St. Stan's (U) is listed in the 1906 City Directory as Methodist, though tradition also says it was Seventh Day Adventist. The letter "G" indicates the Washington Public School.

This is a very "grainy" closeup of the original altar in the present St. Stanislaus Church.

Seen here is St. Stan's Church and "old" school before paved streets (but after the original school of the 19th century).

Stanislaus Kostka was born in Rostkovo, Poland, in 1550, and died before his 18th birthday in 1568. From early youth he was studious and had a great devotion to Jesus in the Eucharist and to Mary. At the age of 14 he went to Vienna to complete his education. There he was treated with abuse by his brother for his piety, which Stanislaus accepted with great humility.

He sought to enter the Society of Jesus at the age of 16, but was refused because his father opposed it. So he walked to Dillingen, Germany, and then to Rome to be accepted into the Society by St. Francis Borgia in November 1567.

His life in the novitiate was extraordinary only for his unfeigned simplicity and the remarkable love that he showed for Christ in the Eucharist. He was often seen in a kind of ecstasy at Mass, particularly after receiving Holy Communion.

In the summer he became quite sick with a fever, a sickness from which Stanislaus predicted he would die. Early in August he was confined to bed where he died on the feast of the Assumption of Mary in 1568. His feast is celebrated on November 13.

There's only one St. Stanislaus Kostka. However, there are many St. Stanislaus churches. One very much connected to the city of Winona is the St. Stanislaus of Warsaw, North Dakota (named after Stanislaus, bishop and martyr, however). It's a huge church, seating 1,200, and also has a two-story brick school hall in a city with a population of only about 300.

The Polish immigration to the area was started about 1873. Ox carts and wagons brought settlers from Perham and Winona in Minnesota, and Pine Creek in Wisconsin, and many immigrants came directly from Poland. They named their city Pulaski.

By 1880, there were over 100 people in the area and later arrivals had to go to the Greenbush, Minnesota, area to find land to homestead. Some of the migrants' names were Simon Tandecki, Francis Kiedrowski, L.A. Kamrowski, Leon Rogalla, Paul Pelowski, Anton Hefta, Martin Moga, Frank Galewski, Jan Czapiewski, and Jos. Stoltman.

Fr. Alexander Michnowski, a former pastor at St. Stanislaus Church in Winona, was pastor there for a short time beginning in 1875. Another of the early pastors was Fr. John Maluski (Maluszycki), born in Winona on October 7, 1887, and ordained June 6, 1914, for the Diocese of Fargo. He was pastor there for 33 years.

Eventually, the name Pulaski was changed to Warsaw. People had to go 30 miles to Grand Forks, sometimes on foot, to get supplies. Six-and-a-half generations separate the people of Winona from their brothers and sisters in Warsaw, North Dakota! Re-establishing the degrees of consanguinity at this point in history is a rather daunting project.

The St. Stanislaus Catholic Church in Warsaw, North Dakota, was erected in 1900 by the Polish settlers of this community, under the direction of Father Gawlowicz. The cost totalled $50,000. It had a seating capacity of 1,200. Stained glass windows, paintings, statues, and interior decorations are all in their original state.

"Montage" of St. Stanislaus

This "montage" includes pictures of St. Stanislaus Church, located in Warsaw, North Dakota. Seen in the upper left: Christmas; lower left: Good Friday (Christ in tomb); upper right: stained glass window; and lower right: main altar under Rose window.

Fr. Stanislaus Duda greets Irene Wieczorek (hidden), Alice Breza, and Leona Bening during an historical foray to Warsaw, North Dakota, from Winona in 1990.

The Church of the Sacred Heart and St. Wenceslaus in Pine Creek, Wisconsin, was founded in 1866. The Polish families who formed this parish came from the same area in Prussian Poland as their Winona cousins.

The 1935 eighth grade graduation class from the Church of the Sacred Heart, located in Pine Creek, Wisconsin, are pictured, from left to right: (seated on floor) Vincent Wnuk, Roman Grulkowski, and Hubert Kramer; (second row) Martha Grulkowski, Edward Kramer, Rev. James W. Gara, Hubert Tulius, and Delphine Stencil; (third row) Arthur J. Tulius, Cyril Pellowski, Evelyn Kukowski (Mrs. Lambert Kukowski), Delores Glodowski, Marie Toshner Mrs. Ralph Eichman), Gregory Kaldunski, and Roy Brom; (top row) Arnold Maliszewski, Emil Kujak, John Peplinski, Romauld Losinski, Hubert Kujak, and Elias Kramer.

Seen here is the St. Stanislaus Convent. It is no longer in existence, but its nameplate can be found in the Winona Polish Cultural Institute.

Some Winona Polish women were pioneers in religious life and served in many locations away from their Winona homes.

S.M. Sabina Kierlin was a School Sister of Notre Dame.

Pictured here is Sister M. Casimir Kosidowski, Sisters of St. Joseph, St. Paul, Minnesota.

Sister Modesta Michalowska is seen here.

Sister M. Marianne Bruski (right) of Sisters of St. Joseph, St. Paul, is pictured here.

Seen here is a church offering record from 1894 to 1908—an indirect genealogical record.

Opłaty złożone

w parafii Św. Stanisława Kostki

WINONA, MINN.

Od roku 1894 — 1908.

:: OFIARY W GOTÓWCE ::

na Nowy Ołtarz i na Sprawy Polskie

w latach 1916 - 1920

W PARAFII ŚW. STANISŁAWA KOSTKI

w Winona, Minn.

Between the years 1916 and 1920, parishioners of St. Stanislaus Kostka Church made contributions to pay for the Carrara marble altar installed in 1920. Prior to that year, a small wooden altar from the original church was used.

47

Opłaty złożone

w parafii Św. Stanisława Kostki

WINONA, MINN.

Od roku 1894 — 1908.

Seen here is the interior of St. Stanislaus Church, with the original open rear windows and side altar.

The parish church of St. Stanislaus Kostka was erected in 1894–1895. The neighboring school was built 10 years later. It was demolished in 1963 to be replaced by the present structure. From time to time, financial reports were issued detailing parishioners' financial support in various areas, such as cost of the altar erected in 1920, on-going expenses related to church and school, and the cost to erect the church itself.

Five

CONTRIBUTIONS TO WINONA, U.S.A.

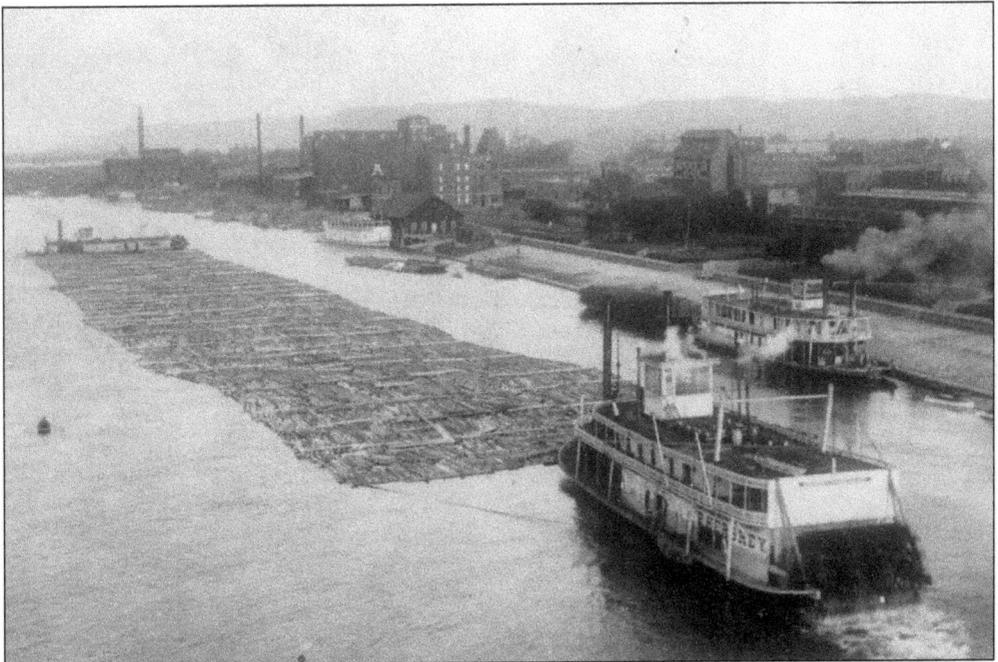

This is a typical log raft being pushed downstream, probably to one of the five lumber mills located in Winona. Such activity ended about 1910, after the pineries in Northern Wisconsin had been denuded. The lumber industry then moved to the northwestern part of the United States.

This Empire Lumber Company crew is "taking five." Ten-hour workdays were the rule. Laborers earned $1 a day; a saw filer was paid $2.50. Youngsters played on the sawdust piles or went swimming off the log rafts after the mills shut down for the day. In the front row, Mike Wieczorek is seated at far right; in the middle row, Joseph Breza Sr. is third from left.

Romuald Kierlin, fourth from left, was a Winona East Ender who found employment in one of Winona's sawmills. The Polish Cultural Institute of Winona is located in the former Laird-Norton Lumber Mill office building.

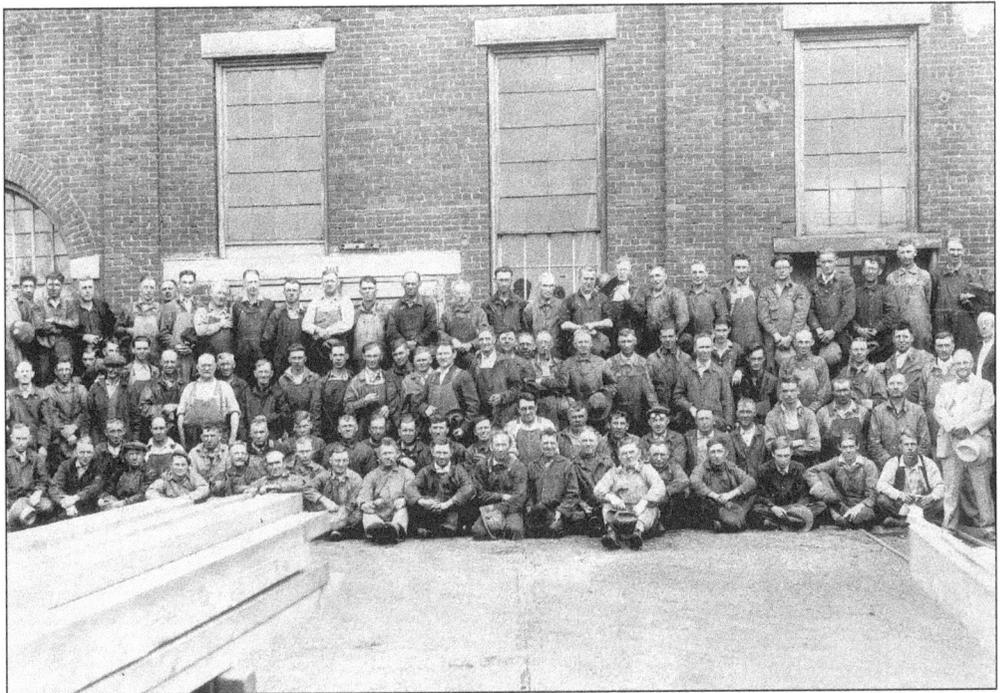

Employees of the Chicago and Northwestern Railroad worked in the western part of Winona until the road went out of business. At one time there were five railroads stopping in Winona for passengers, mail, and freight.

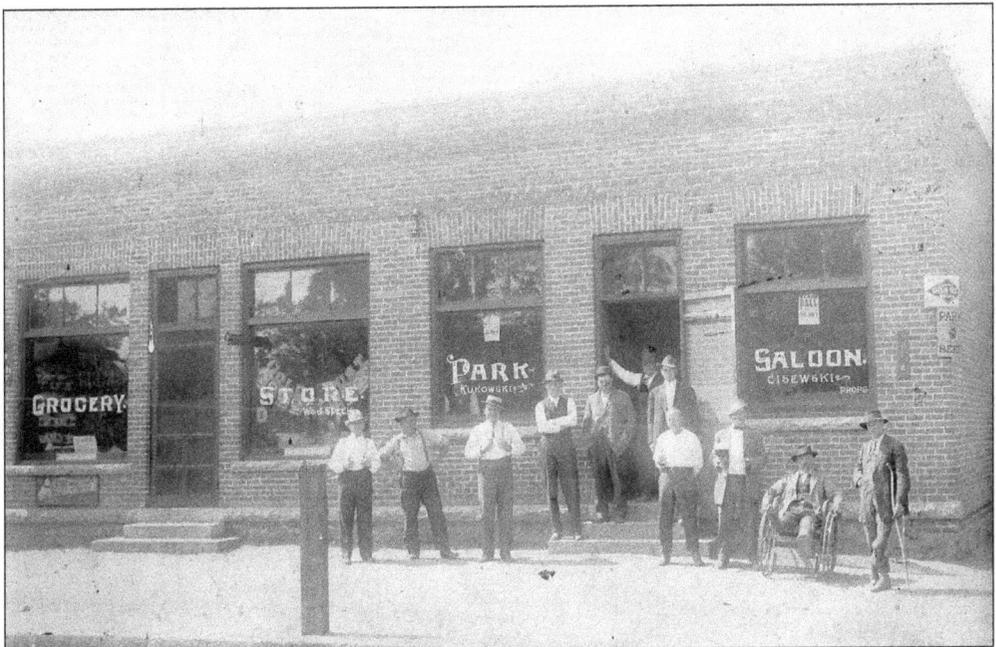

In the early 1900s, William Speck owned the building and the grocery portion of this complex on King and Chatfield Streets in Winona's East End. Messrs. Kukowski and Cisewski shared the rest of the premises to mutual satisfaction.

This blacksmith shop was owned by Joseph Kulasiewicz, father of Ray Kulasiewicz. The shop was located at the corner of Sugar Loaf Road and Highway 43.

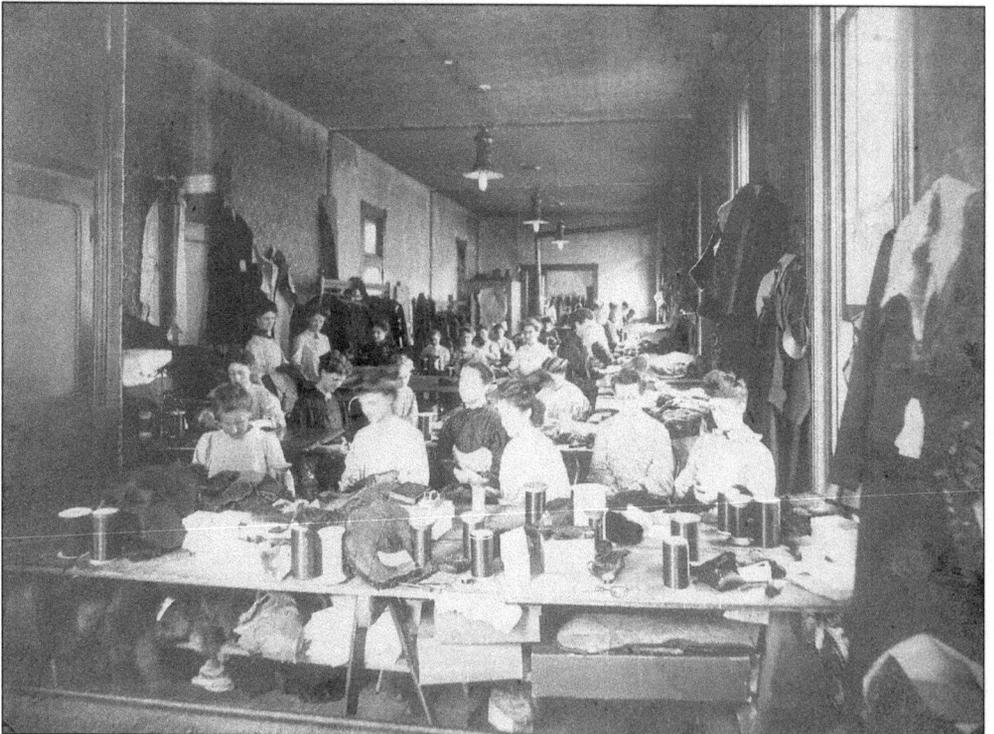

The workroom of the Conrad Fur Store is seen here, c. 1900. There were not many places of employment available for young women at this time. They found jobs as seamstresses, clerks in stores, and domestics.

Frank L. Cierzan was born on October 4, 1872, in the village of Oslowa Dabrowa, a parish of Bytow in Prussian-occupied Poland. He came to America with his parents at the age of seven and settled with them in Winona's East End in the parish of St. Stanislaus Kostka. In due course, he worked as an assistant millwright at the Winona Lumber Company near his home. After 14 years with that company, he left to establish his own business, a dry goods store which he and his wife operated until his death. He married Mary (Mae) Zaborowska in 1893. In addition to operating the business, Frank served two terms as alderman from his ward. He also was active in several parish societies. He died on July 26, 1926, at the age of 53.

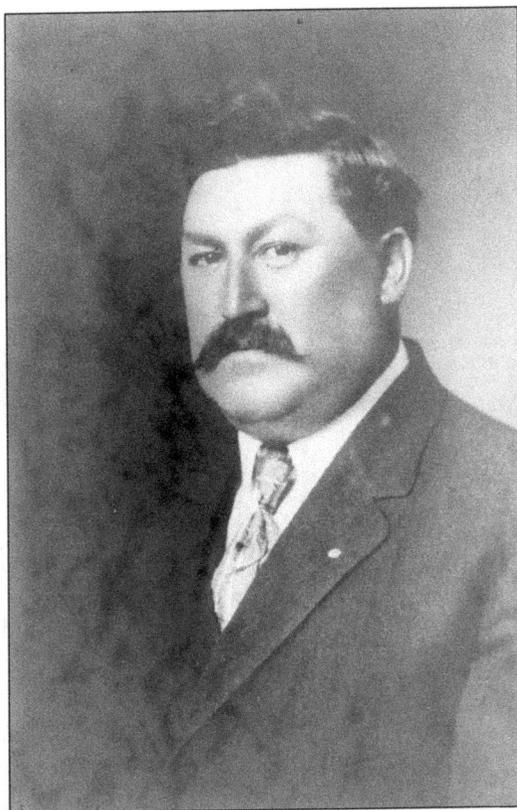

Below is the interior of the F.L. Cierzan Store, 603 East Fifth Street. Mrs. C. is standing at far left, Mary (Mrs. Tony Katula) is seated. Others are unidentified.

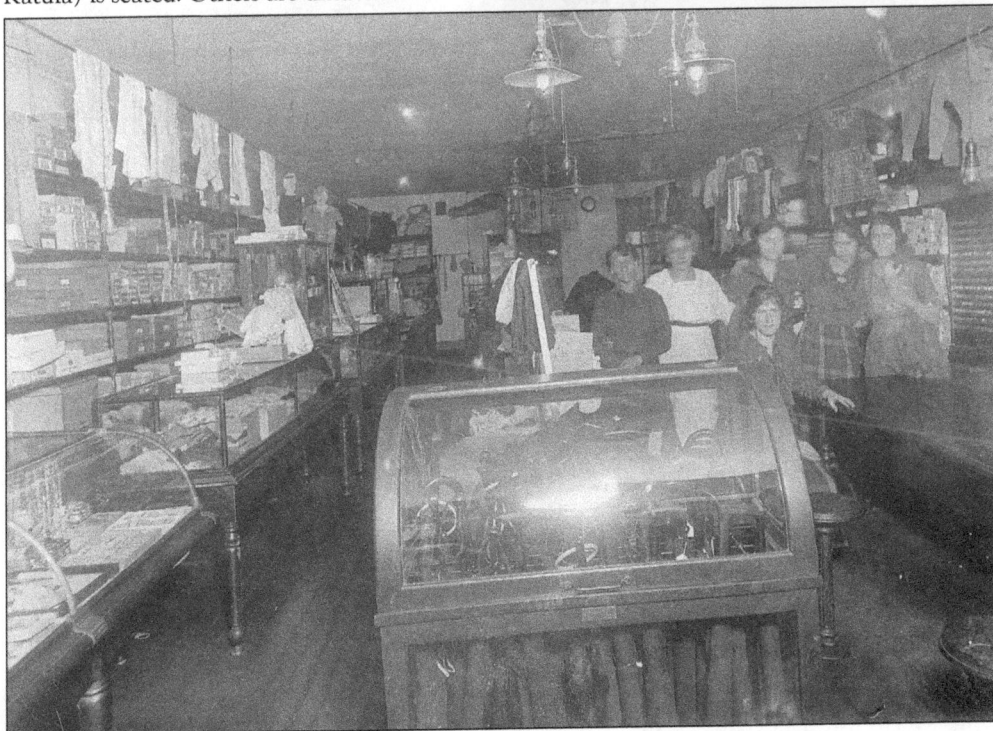

The Cierzans employed ladies who could turn out wedding dresses and First Communion dresses. F.L. Cierzan and his wife Mary (Mrs. C.) are third and fourth from left.

St. Stanislaus Kostka was well represented among the firemen around the turn of the century.

Peerless Chain Company was founded in 1918 to provide tire chains for use on icy roads. The firm began under the leadership of John Bambenek and his son Dominic "Dick" Bambenek. They were joined by Dick's brother Joe after he mustered out of the army, and another brother Al from the navy after World War I. It continues in business to this day.

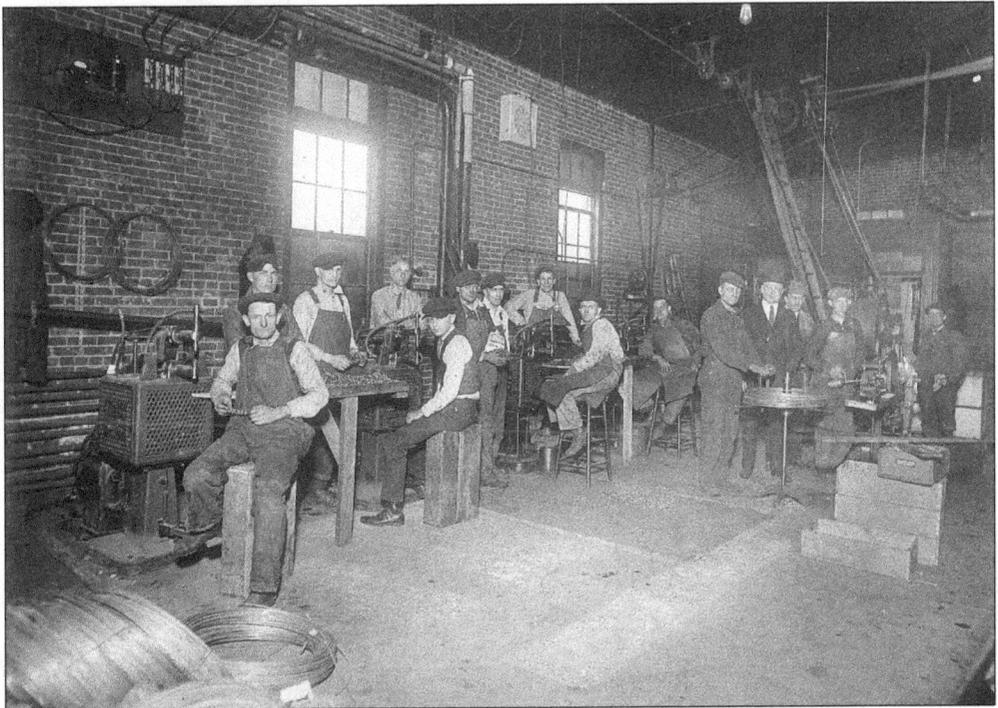

Pictured is the Peerless Chain in the late 1920s.

An East End Winona landmark was the Cichanowski Jewelry and Barber shop on Mankato Avenue, just off Broadway (Sixth Street), across from the Polish Stock.

The jewelry business began in 1906. Felix had been trained in Chicago as a jeweler but also did barbering. By 1912, Felix and Joe were in business at the Mankato Avenue address and John was a clerk at Hillyer's Furniture and Mortuary in downtown Winona. In due course, John joined his brothers as a barber. Joe died in 1941 at the age of 58, and his wife Stella took his place. She operated the jewelry business until 1953.

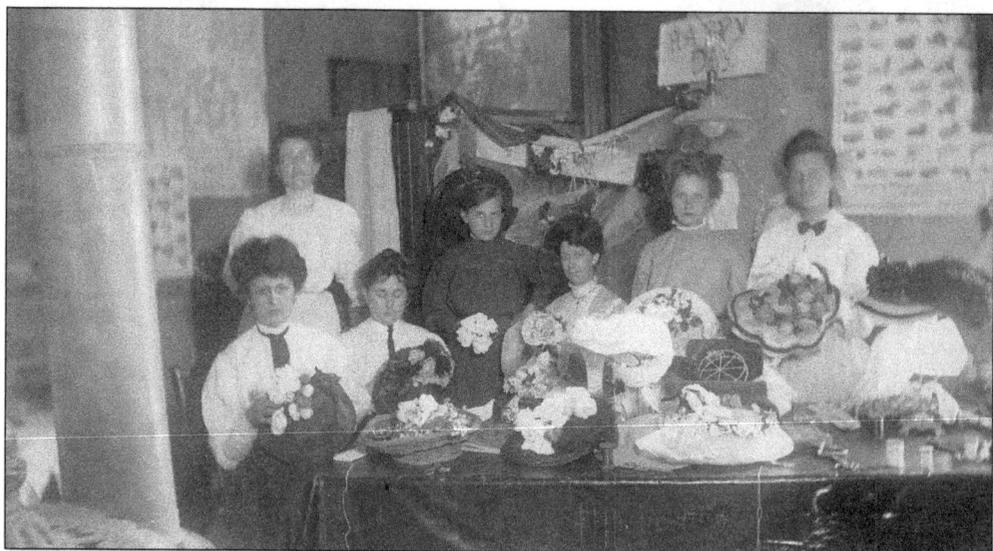

Helen Cichanowski Faber operated a millinery shop at 623 East Fifth Street in 1912. Two years later she moved downtown. Meanwhile, her sister Agnes had been a clerk at The Fashion, a women's clothing store in downtown Winona. By 1921, Helen had moved her shop to 526 East Fourth Street and Agnes was clerking there but was to remain for only a few short years. She died in 1926. Helen continued her business until 1929. Helen is shown seated at the left end of the front row.

Pictured is Helen's Millinery Shop within the shadow of her parish church of St. Stanislaus Kostka.

In 1887, Joseph Jereczek and some like-minded friends combined their resources to establish a grocery and general merchandise store called Polish Stock. A building was erected at the corner of Mankato Avenue and Broadway (Sixth Street). In addition to the business on the main floor, there was a meeting hall on the upper floor, and later a mortuary in the rear. In due course, Jereczek bought out his partners and became sole owner. Elsewhere in the community, he was appointed to the first Board of Fire and Police Commissioners, serving from its founding in 1915 until his death in 1937. He was alderman from his ward from 1899 to 1903, and from 1911 to 1915. In his parish of St. Stanislaus Kostka, he served on the building committee of the new church, which was erected in 1894–1895, and was active in a number of other organizations in the parish and in the community at large.

Peter Merchlewitz, founder of Winona Dray Line, was born September 3, 1891, and died on January 25, 1956, at the age of 64. He was a member of the First District Board of Commissioners from 1952 until his death.

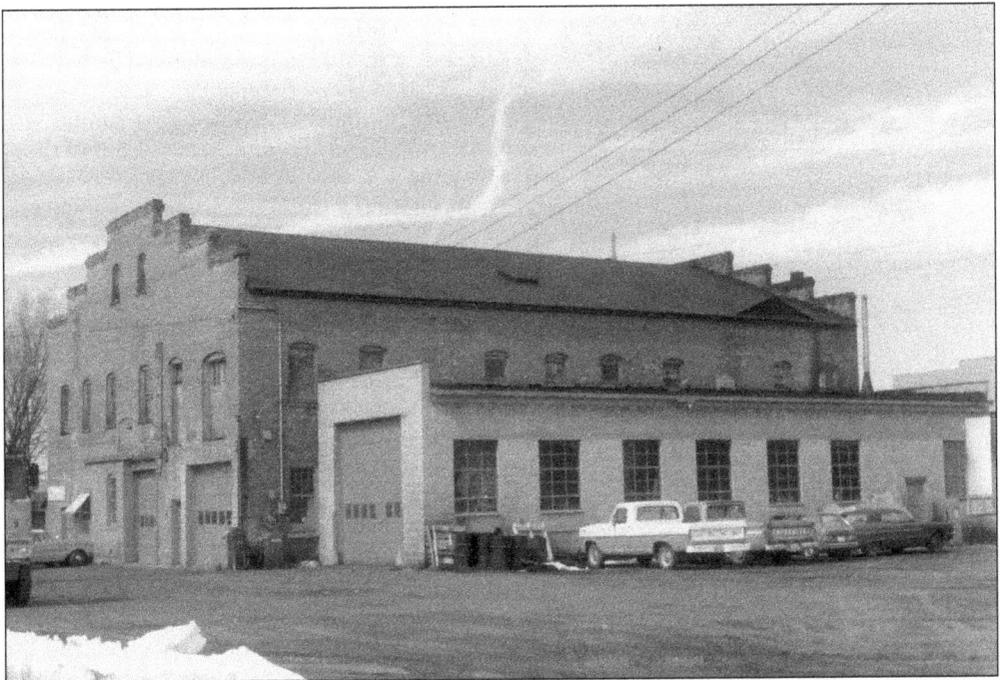

Winona Dray Line, located at Front and Carimona Streets in Winona, was founded in 1922.

Najuprzejmiej zapraszam

na uroczystość mej

Pierwszej Mszy Świętej

którą odprawię

w niedzielę, dnia 30-go sierpnia 1914 roku

o godzinie 10-tej

w kościele Św. Stanisława Kostki

w Winona, Minn.

Tudzież na gody które odbędą się

w domu matki 858 wsch. Piąta ul.

Z głębokim szacunkiem

Ks. Maksymilian M. Klesmit.

Seen here is a souvenir of Rev. Maximilian M. Klesmit's first Mass, on August 30, 1914, in the church of St. Stanislaus Kostka.

The Watkowski Funeral Home, one of the oldest in Winona, was founded by L.J. Watkowski on February 4, 1913, in the rear of 216 Mankato Avenue. The family grocery store was operated in the front of the building. Prior to establishing his business across from the present location of the funeral home, Mr. Watkowski had a store in the block facing Mankato Avenue where the Washington-Koscziusko School now stands.

At the encouragement of downtown businessman Harry Krier, L.J. Watkowski established a business as a mortician. In 1928, his daughter Henrietta obtained her embalmer's license and joined her father in the firm. Her brother, Joseph R. Watkowski, completed the course in Mortician Science at the University of Minnesota in 1934, and he too was added to the staff. In 1940, the present structure at Fourth Street and Mankato Avenue was built.

L.J. Watkowski was born in Osiek, Poland, on June 27, 1875. He married Victoria Jaszewski on May 4, 1898. He died on April 18, 1937, at the age of 61, having been in business for 37 years.

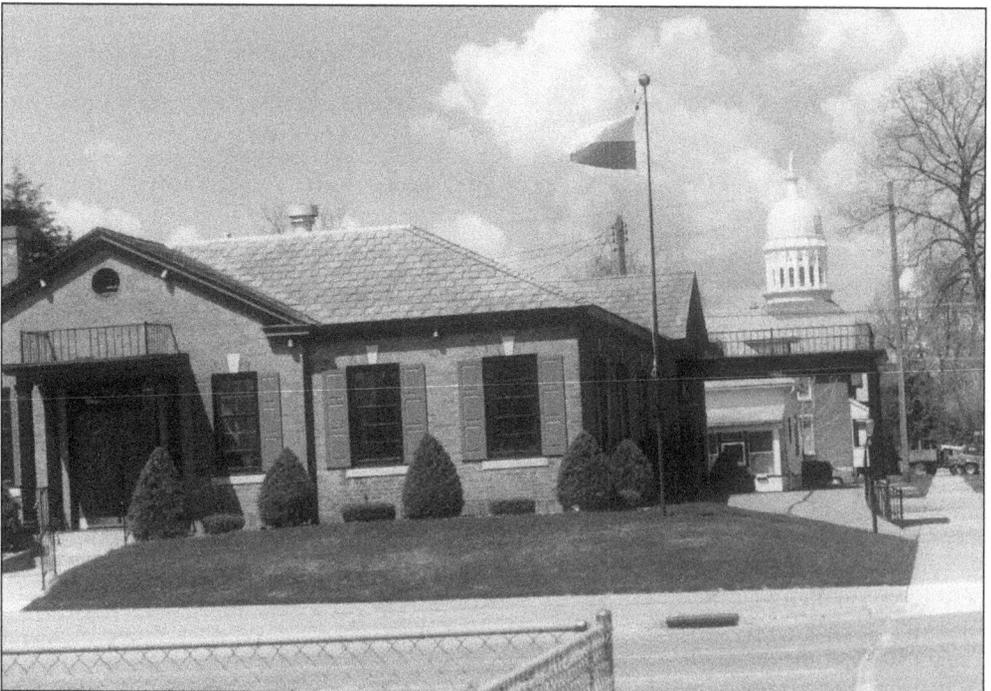

This picture of Rev. Joseph Cieminski is dated August 25, 1902. He was Father Pacholski's assistant from 1895–1902, and made pastor of St. Stan's in 1931. In 1946, he resigned to enter St. James Hospital. His monsignor sash and breviaries, as well as his cigar humidor, articles, and awards from Poland are on display at the Polish Cultural Institute, Winona, Minnesota.

On June 5, 1966, lightning struck the dome of St. Stanislaus Church, causing much damage to the interior of the dome area. Considerable water damage was done to one of the pillars and to many of the pews in the church itself.

Seen here is the main dome interior after the fire.

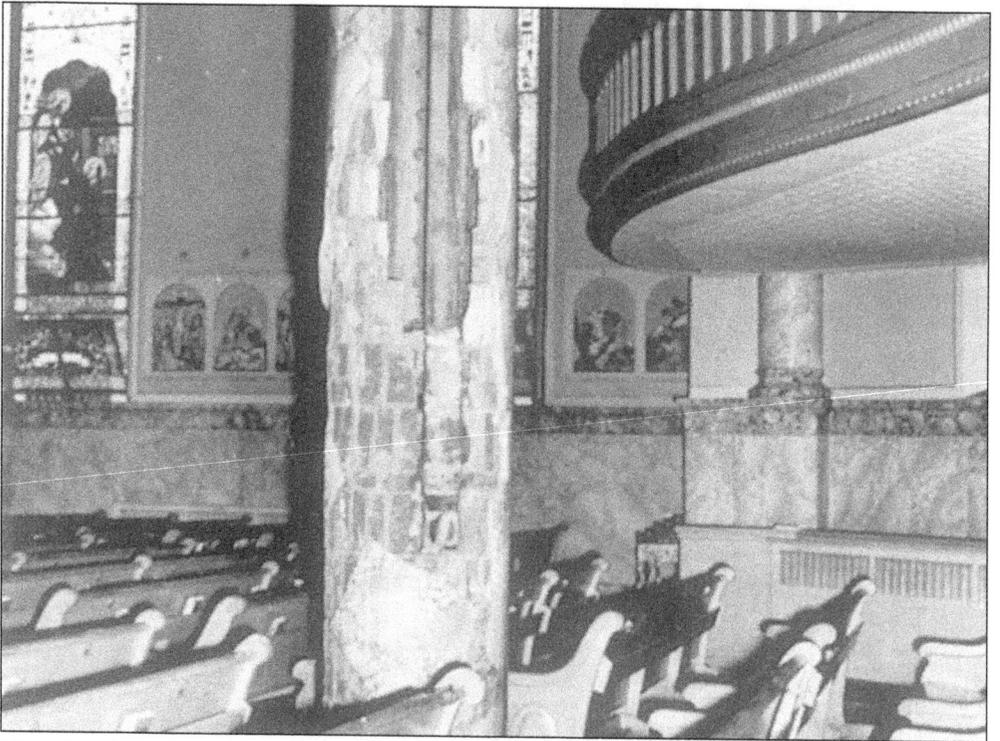

This church pillar suffered severe water damage.

Seen here is Rev. Nicephore Grulkowski offering a prayer of thanksgiving following the fire.

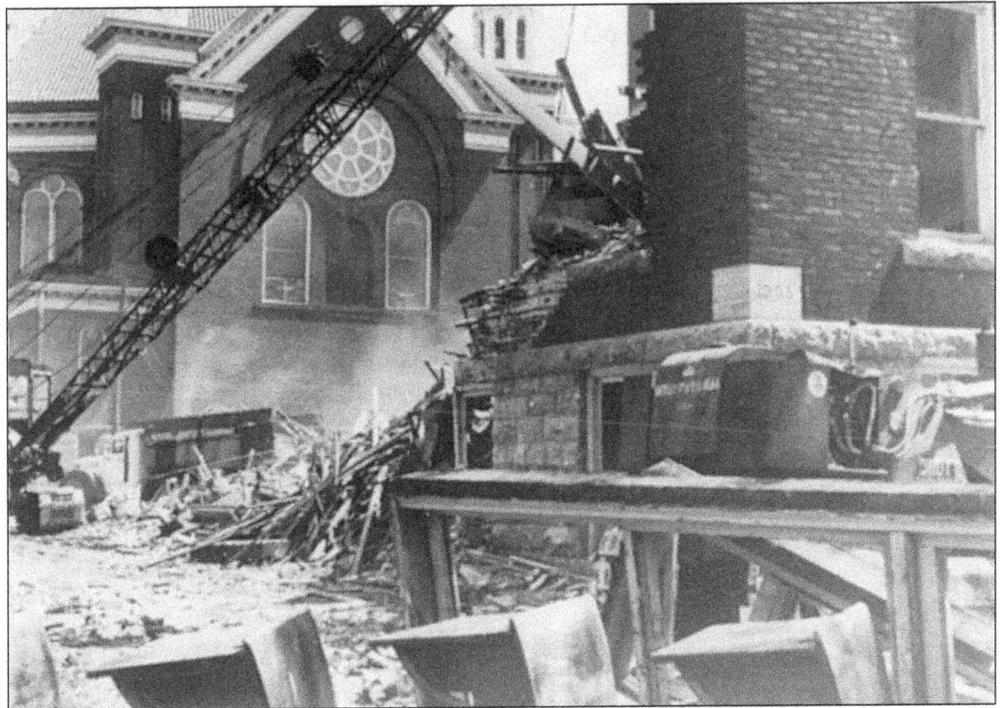

St. Stan's School, built in 1905, was razed in the early 1960s.

Seen here is the new school addition of 1965-1966.

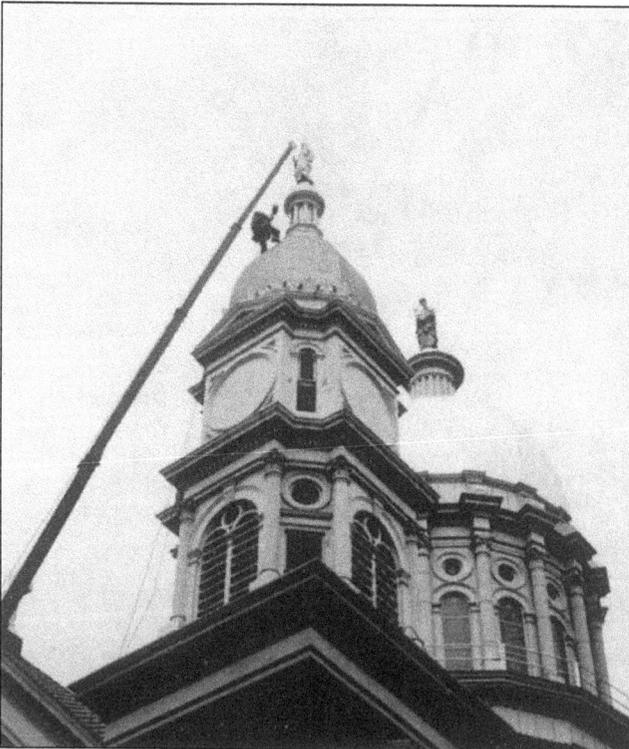

Pictured is an example of hard work in a risky position.

Pictured here is a workman applying a new coat of paint on top of it all.

The 170-foot-high main dome was refinished to gleam for miles around.

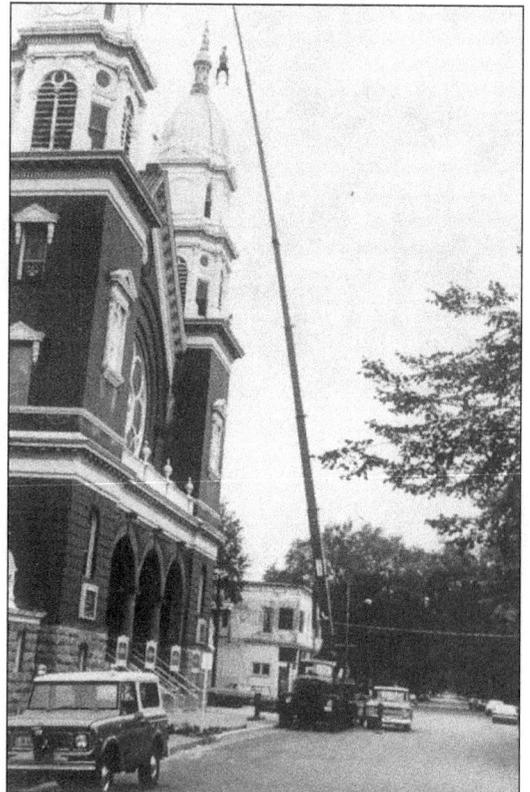

A Dynamic Fluid Power Co. hoist suspends this painter 115-feet above the street.

Six

EXTRA-CURRICULAR

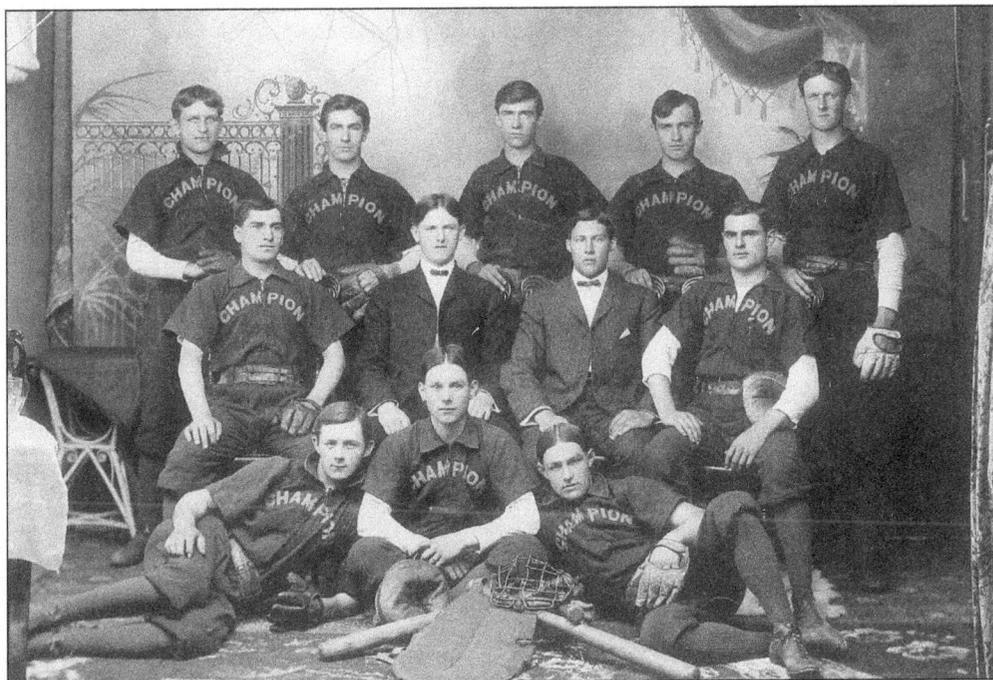

The Champion Baseball Team played their schedule in Winona's Athletic Park in the West End of town. Most of the team was made up of men from both St. Casimir and St. Stanislaus parishes. Pictured, from left to right, are as follows: (front row) Jack Knopik, W.T. "Rose" Joswick, and Henry Peterson; (second row) Mike Yahnke and Rudy Bohn; (top row) John Wrycza, (?) Cisewski, and Pearl Cierzan.

Note the difference in the size of the bats used by the members of the Married Men's Baseball Club during a Sunday afternoon game. One wonders if it was baseball or softball that these men played. A few of the men are as follows: (front row) Joseph Jereczek, with dog; (second row) Mike Bambenek Sr., the first person seated on the left; Michael Yahnke, wearing white suspenders and dark shirt, and F.L. Cierzan, bat leaning against leg.

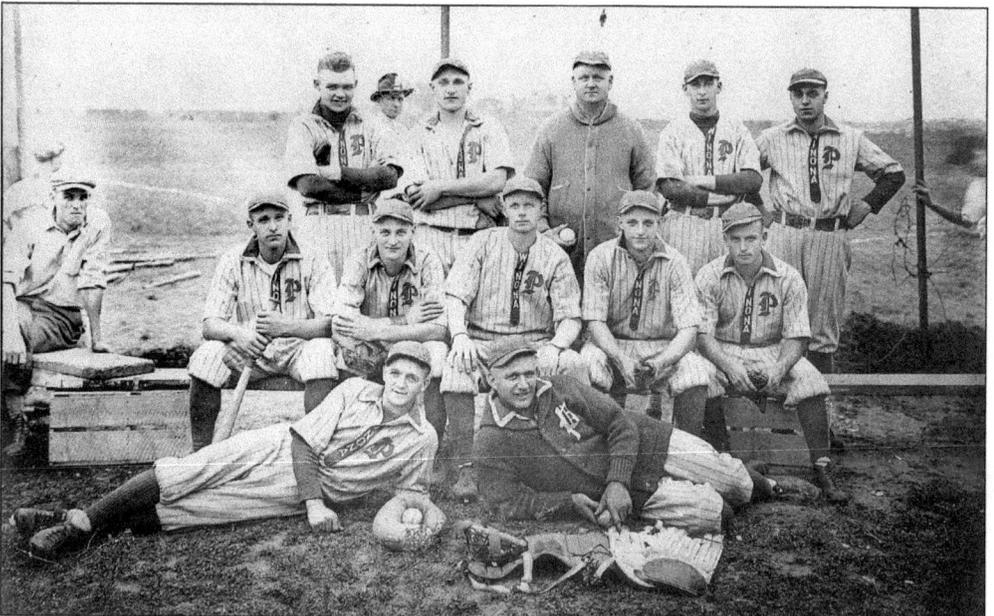

The Peerless Chain Company Baseball Team is seen here c. 1921–1922. Pictured, from left to right, are as follows: (front row) Frank Wally, catcher, and Mark "Cannonball Moss" Mauszewski, pitcher; (second row) Max "Brownie" Kulas, Al Grochowski, Emil "Pinch" Edel, Paul "Sabe" Nigbur, William "Wild Bill Corbett" Czaplewski, and Joe "Jess Scott" Skuczynski; (top row) John Chapman, Max "Fox" Grochowski, Pearl Cierzan, Pete Edel, and Frank Lelwica.

Historically, baseball was a popular sport in Winona. A ballpark was located in both the East End and the West End of town. For a time the Polish National Alliance sponsored a team that played teams in Southern Minnesota. Shown here is the 1928 Junior Legion Baseball Team of Winona. The players, from left to right, are as follows: (front row) "Spud" Rivers, Stan Czapiewski, Bill Hargesheimer, Mark Michalowski, and Don Walski; (second row) Edward "Ebie" Bernatz, Joe Dernek, John "Sacky" Sadowski, and Ches Cichosz; (top row) Jim Pomeroy, Hubert Kleinschmidt, Gene "Corbett" Czaplewski, and Connie Wroblewski.

Julian Wera, a Winona native, was a member of the 1927 world champion New York Yankees.

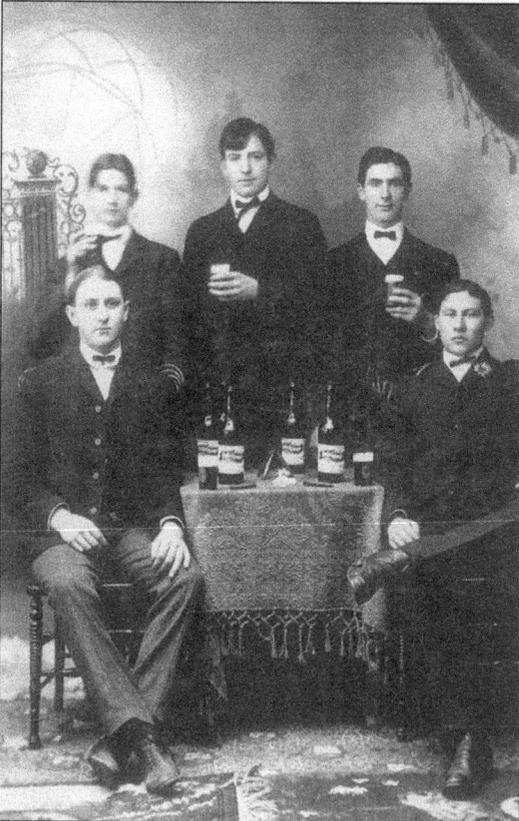

Chester Wieczorek attended St. Mary's Preparatory School, Orchard Lake, Michigan, where he starred as a student and athlete, graduating in 1933. He played football at St. Mary's College in Winona and Winona Teachers College, now Winona State University. In 1935, Ches entered professional baseball in the Northern League as a third baseman for the Superior (Wisconsin) Blues. Following that, Ches played catcher for the Wausau (Wisconsin) Lumberjacks in the same league. Shortly after, he left semi-pro ball for a job in industry. Chester is pictured on the right.

Michael Yahnke, seated on the right, and his friends pose for a photo during a sociability session. They are promoting Bub's Beer, produced in a brewery located on Winona's southeast side, which employed members of St. Stanislaus Parish.

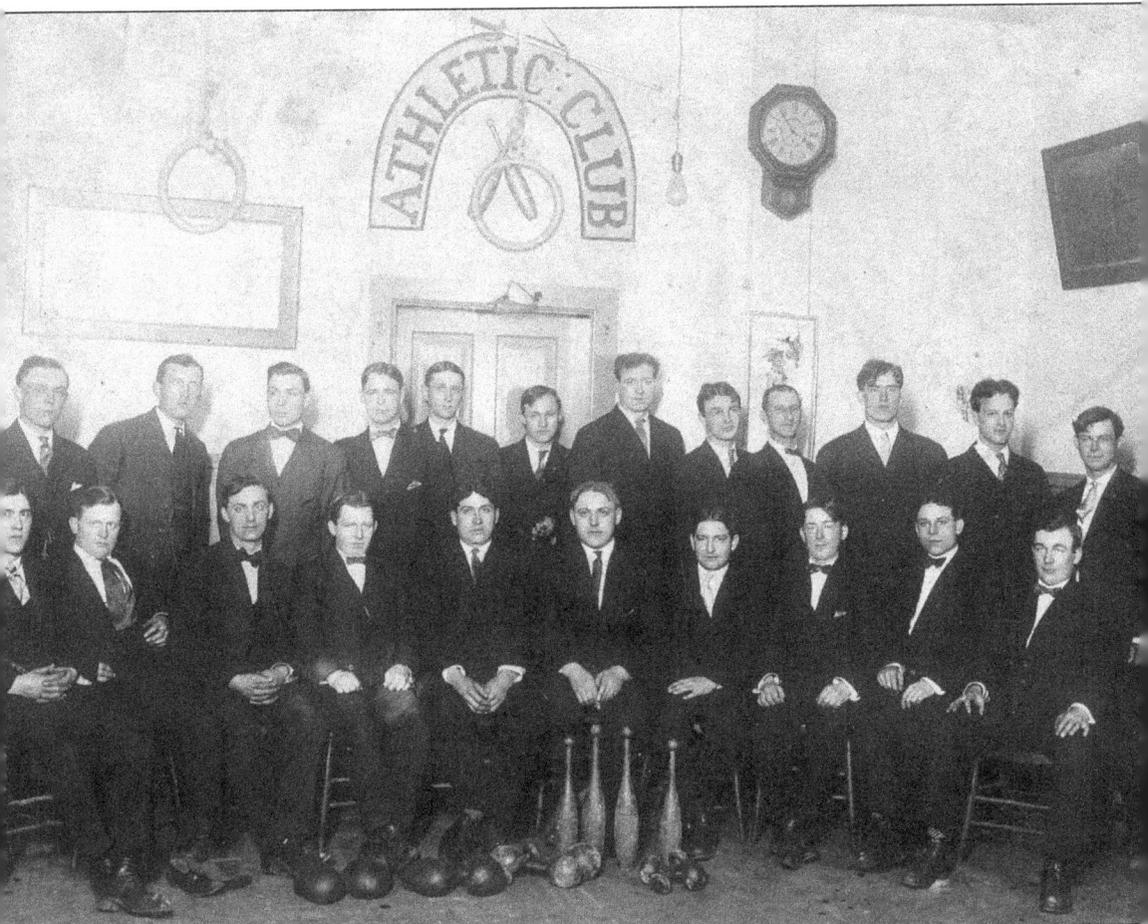

The Winona Athletic Club was the center of Fourth Ward social activity, what with dances, bowling leagues, wedding receptions, and the like being held on a regular basis. Other athletics were part of the club life, but limited to bowling, baseball, and kittenball (softball). The club was founded in 1895 by 10 young men. They met in a "summer kitchen" in an East End Winona yard. Shortly after World War I, membership had increased to 35. Early on, the club was housed in various locations because of the need for more space caused by increasing membership. By 1927, it became clear that a more substantial building was needed. Accordingly, plans were drawn up to provide for the present building at Mankato Avenue and Fifth Street, which was completed and dedicated in 1931. Members of the first Board of Directors were: Theodore Bambenek, Henry Kowalewski, Klemens Owecke, Leon Watkowski, and Michael Lipinski. Officers were Stanislaus A. Wiczek, president; Felix Watkowski, first vice-president; John Kowalewski, second vice-president; Alex Wicka, secretary; and Charles Trubl, Sr., treasurer.

Through the years, the club has supported baseball and bowling teams and has provided a venue for a wide variety of social functions. This picture was taken in 1922 in the basement of Radecky Hall, formerly located on the corner of East Wabasha and High Forest Streets. The club members shown here, from left to right, are as follows: (front row) unidentified, Sam Mlynczak, Ted Bambenek, unidentified, Ted Lica, Bill Chuchna, Kim Owecke, unidentified, W.T. "Rose" Jozwiak, unidentified; (top row) Mike Lipinski, Walter "Blood" Osowski, Ted Lipinski, Joe Ball, three unidentified men, Leo Watkowski, unidentified, John Koscielski, Charles Trubl, and Mike Knopick.

Pictured is a Sunday afternoon band party, complete with suitable refreshment to lubricate Polish tonsils.

Pictured, from left to right, are as follows: Blanche Szudera, Liz Liberko, Dego Palbicki, Rich Srnec, unidentified, Emma Becker, and unidentified—all part of a group called OOKLIZUMPS . . . a small social club that never succeeded.

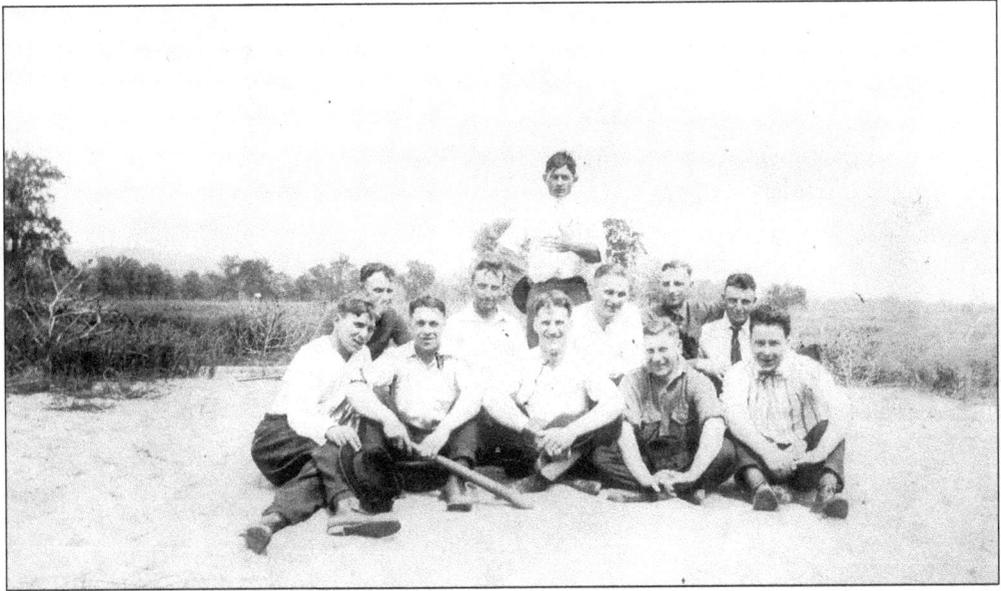

The men in this picture, from left to right, are as follows: (front row) Murt Murtinger, Frank Lelwica, Vince Breza, John Breza, and (?) Srnec; (second row) (?) Janikowski, (?) Cada, (?) Maroushek, and (?) Milanowski; (top row) Dago.

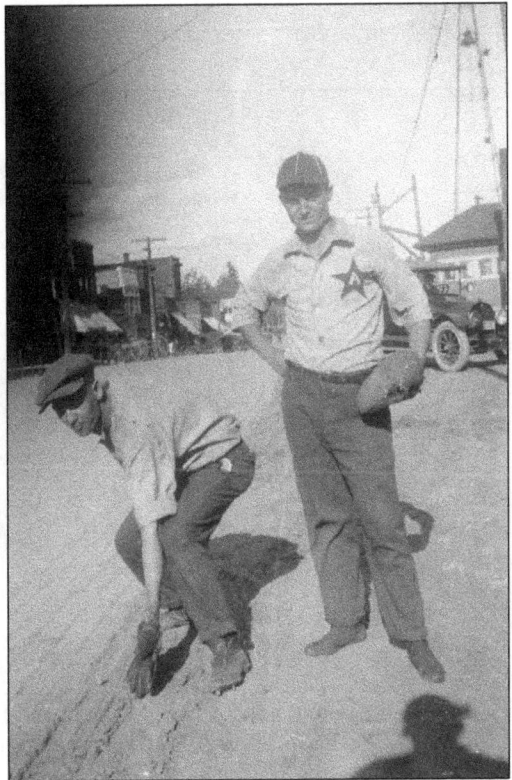

Pictured here are Kelly Gabrick and Joe Rozek.

Nixy Srnec is seen here on Lokowicz Corner. Nixy was a good Bohemian friend to many of the Polish young men of his day.

Pictured, left to right, are as follows: (front row) Harry Cierzan and Betty Liberko; (second row) Lydia Bronk, Stella Breza, Emil George, and unidentified; (top row) (?) Murtinger, unidentified, (?) Schneider, Rich Srnec, and (?) Tribbel.

Jack Holmay and Frank
Maroushek are seen here.

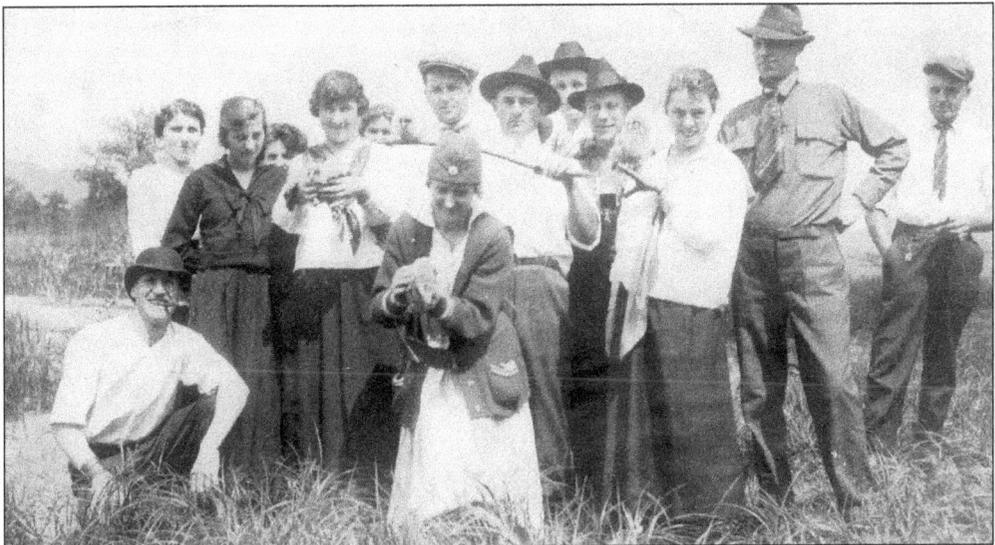

The people identified in this photograph, from left to right, are as follows: Vince Breza (kneeling) with Josephine behind him, Betty Liberko, Blanche Szudera (holding owl), Stella (Breza) Miller (front, center, also holding owl), Dago (center, holding stick with owl), John Breza (fourth from right), Emma Becker (holding short stick with owl), (?) Janikowski (second from right), and Joe Rozek (far right).

Who are these three musketeers?

Pictured here, from left to right, are as follows: Kelly Gabrick, Joe Breza, Al Paroda, Joe Rozek, and Art Hrubetz.

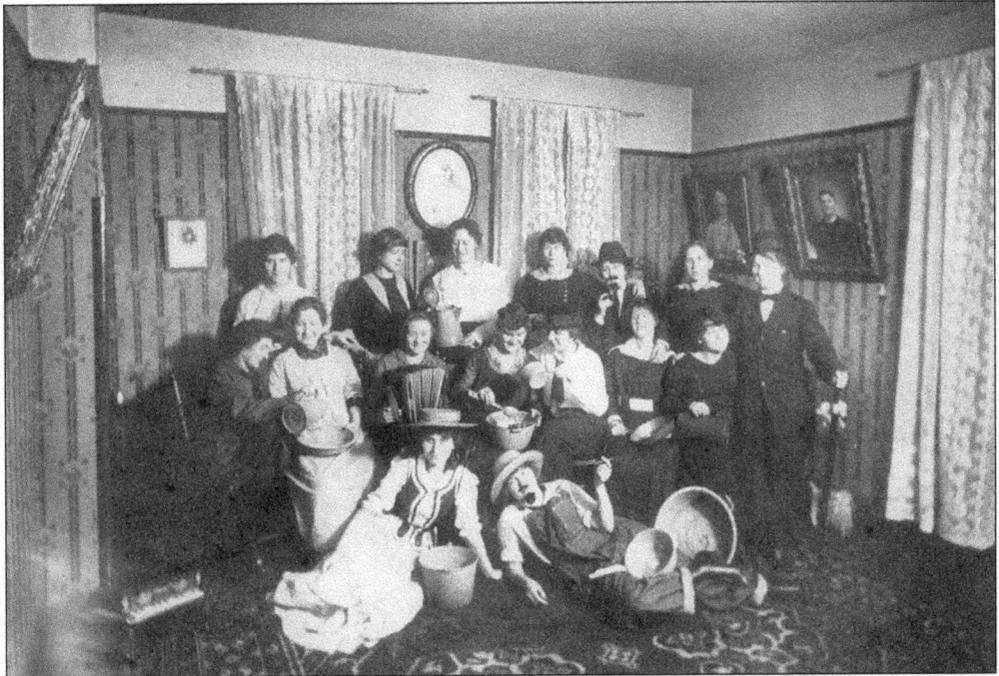

Neighborhood ladies, some related, got together for a bit of domestic frivolity. Note the absence of males and two ladies in men's attire. The group is known as a washtub band. Note also the pictures of Pope Leo XIII and that of pastor Msgr. J.W. Pacholski in the background.

ARIA CHOIR JULY 5, 1915

In 1915, the Aria Choir was comprised of St. Stanislaus Parishioners who enjoyed an outing on the outskirts of Winona. This occurred early during World War I, so more men were present than would be two years later. Some members were Leon Bronk, Josepha Kowalewska Contoski, Natalie Jezewski, Henry Kowalewski, Harry Muras, Agnes Rogalla, Jess Scott, and L.J. Watkowski.

The Onward League was a group of young women from St. Stanislaus Parish who were members of Dzieci Marii (Children of Mary). They gathered in the church basement for their social activities. The president was Josephine Kowalewska. The group was founded by her sister, Monica Kowalewska, later Monica Krawczyk, an author. Josephine was an educator, translator, and also an author. She and another sister, Cecily Kowalewska Helgeson, were among the original incorporators of the Polish White Eagle Association in Minneapolis in 1927.

The young men in the parish also had a social group which met above Szulta's Millinery Store. Msgr. James Pacholski supported both groups. The ladies in the photo, from left to right, are as follows: (front row) Mayme Cierzan, Mary Tabat or Angeline Potratz, Genevieve Stoltman, (?) Kosidowski or Mary Burant, three unidentified women, Agnes Grochowski or Cassie Ryszka, and Blanche Walski; (second row) Dorothy Fisher, Agnes Cieminski, Florence Cisewski, Fran Gostomski, Laura Skuczynski, Tecla Burant, Josephine Rogalla, unidentified, unidentified, Helen Edel, and two unidentified women; (third row) Gert Stoltman, three unidentified women, Mary Masyga, Catherine Czaplewski, Millie Wieczorek, Helen Gabrych, (?) Szewel or (?) Kulas, Clara Masyga (holding arm over Stella Breza), Stella Breza Miller, and (?) Rosinski; (top row) Eugenia Czaplewski, (?) Wyrdych, (?) Palbicki, unidentified, (?) Cysewski, Harriet Derdowski, two more unidentified women.

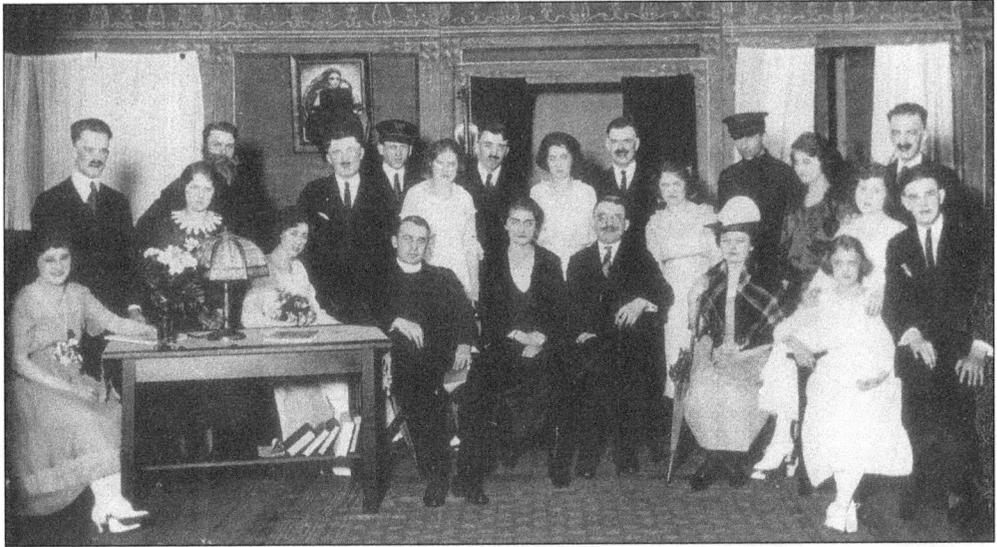

One of the organizations in the parish of St. Stanislaus Kostka was the Polish Dramatic Society. It was founded in 1881 by the following members of the parish: John Zaborowski, A.F. Glubka, and A.F. Blagik, with Mr. Zaborowski being the "prime mover." One of their members, (?) Kowalski, had the distinction of having had a play published. The group gave their first entertainment, *Love's Revenge*, on April 6, 1883, at the Philharmonic Hall in downtown Winona. By the fall of 1885, the group had grown considerably and completed their own building on High Forest and Wabasha Streets. It was one of the most active and long-lived social groups in the parish, remaining active in the community until the 1920s. In 1895, they sponsored the two stained glass windows behind the main altar of St. Stanislaus. Pictured, from left to right, are as follows: (front row) Mae Masyga, Genevieve Cierzan; (seated) Rev. Leon Hazinski, Natalie Jezewski, John Bambenek, Florence Cisewski, Frances Maliszewski, and Hubert Weir; (top row) Max Ramczykowski, Sophie Palbicki, Leon Bronk, Clarence Miliszewski, Ed Molski, Frances Kujak, James Wera, Gertrude Sadowski, unidentified, Stella Palbucki, Bill Molski, Dorothy Fischer, Emily Czaplewski, and Carl Jeruzal.

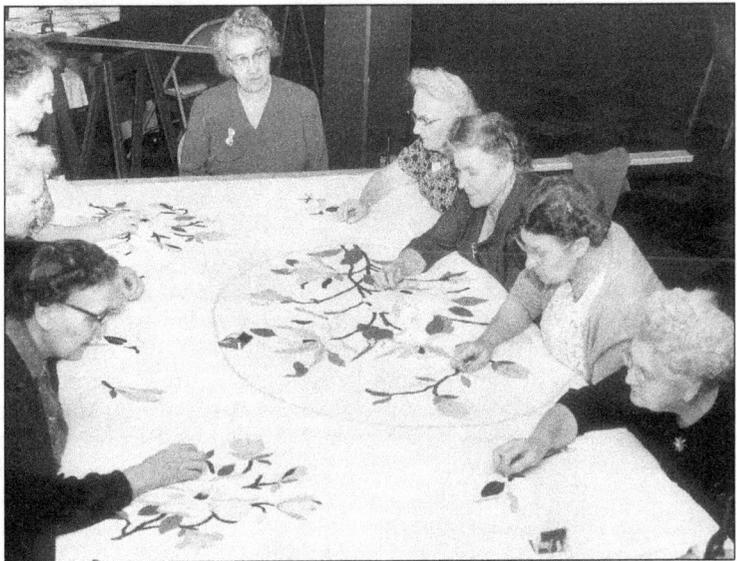

Each year parish ladies gathered in the church hall of St. Stanislaus Kostka to produce attractive quilts to be offered as prizes in the annual November bazaar. Pictured, left to right around the quilt, are as follows: Victoria Watkowski, Helen Lejk, Anna Knopick, Helen Szlagowski, Helen Kowalewski, Valeria Watkowski, Pauline Maliszewski, and Mary Kramer.

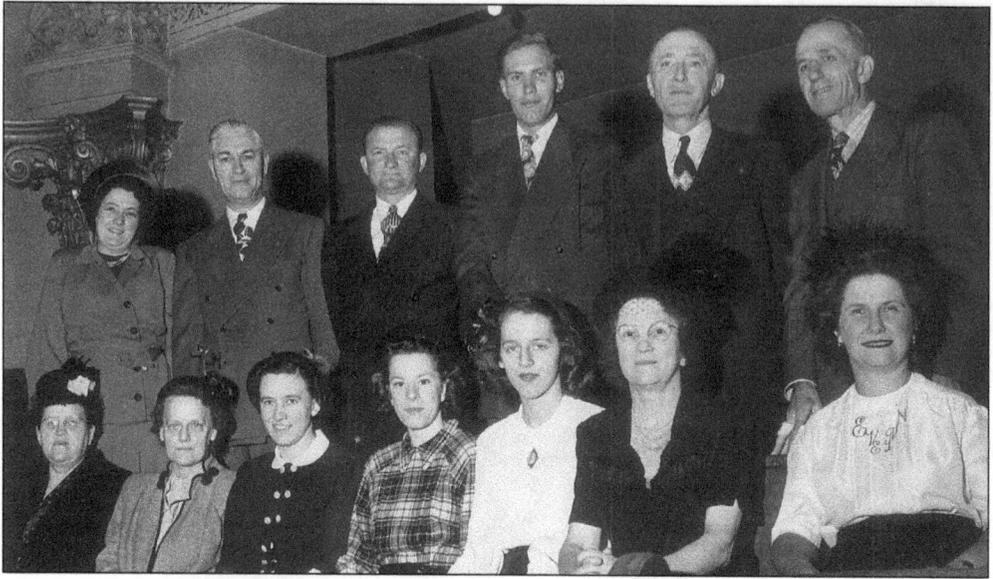

The St. Stanislaus Mixed Choir, from left to right, are as follows: (front row) Mrs. Anna Pehler, Frances (Gostomski) Maliszewski, Irene Wieczorek, Rita Ramczyk, Rita (Galewski) Wilson, Helen Weir, and Evelyn Herrman; (top row) Mrs. Hubert Weir, Lawrence Jaszewski, Daniel Janikowski, Raymond Bambenek, Clarence Maliszewski, and Frank Cisewski.

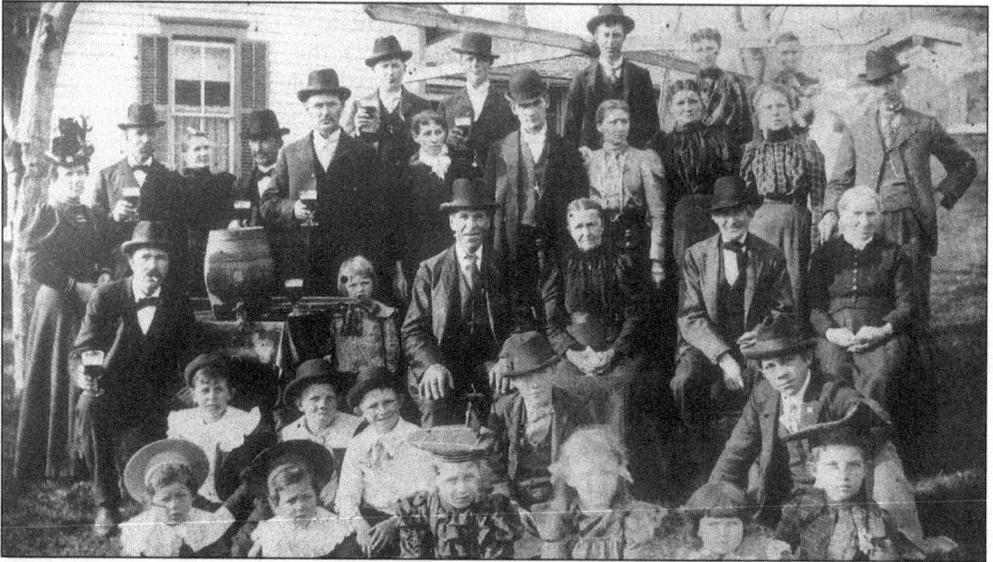

These people all bear good Pine Creek names of yesteryear—but what was the event? Pictured, from left to right, are as follows: (front row) twins Peter and Paul Brom, two Jaszewski or Brozinski girls, Vera Brom, and Rose Brom Hoesly; (second row) Harry Brom (boy with larger hat), Frank Stencil, Vince Borbosk, and Peter Lorbeski; (third row) Martin Brom, Lawrence Jaszewski, Mr. Mathew Brom, Mrs. Mathew Brom, Mr. and Mrs. Brezinski—parents of Mrs. Frank Brom, Joe Brom, and Paul Brezinski; (fourth row) Mrs. Martin Brom, Frank Brom, Mrs. Frank Brom, Joe Brezinski, Frank Jaszewski, Mrs. Jaszewski, Mr. and Mrs. Lile (who could be Joe Brezinski's sister), Mrs. Weir, Rose Brom, and Mr. Weir; (top row) Paul Brezinski, Martin D. Brom, John F. Brom, Mrs. John F. Brom, and Mrs. Paul Brezinski.

80

Seven

SCHOOL ACTIVITIES

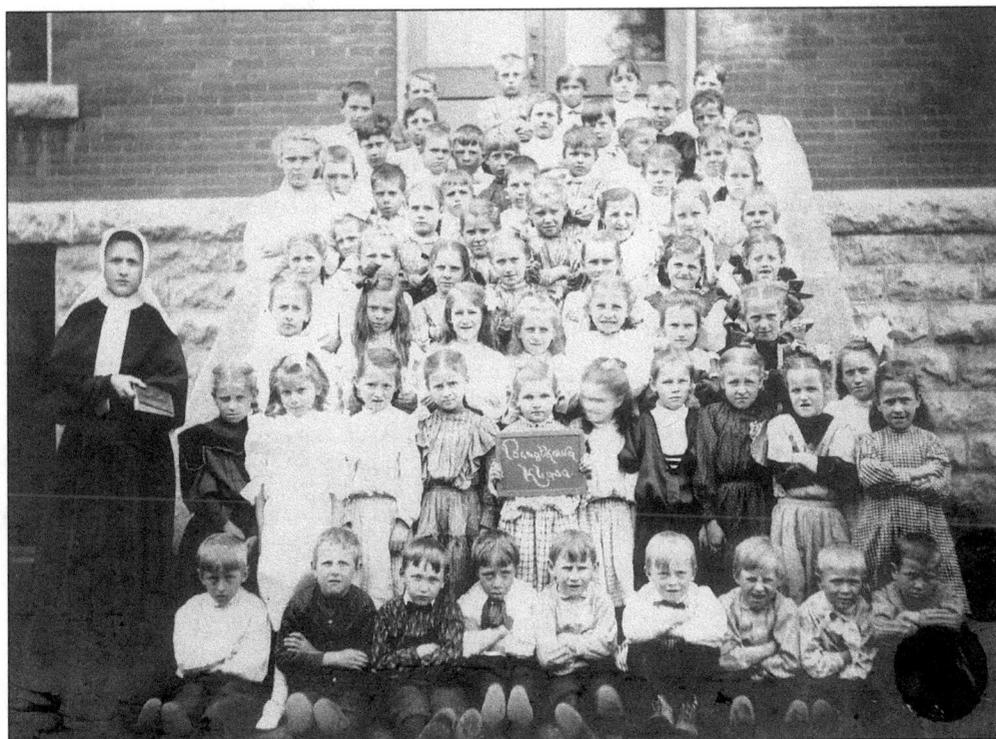

The "new" St. Stanislaus grade school was built in 1905 to replace the two-story frame structure. This photo shows the "Beginner's Class." These scholars had been enrolled at the nearby Washington Public School.

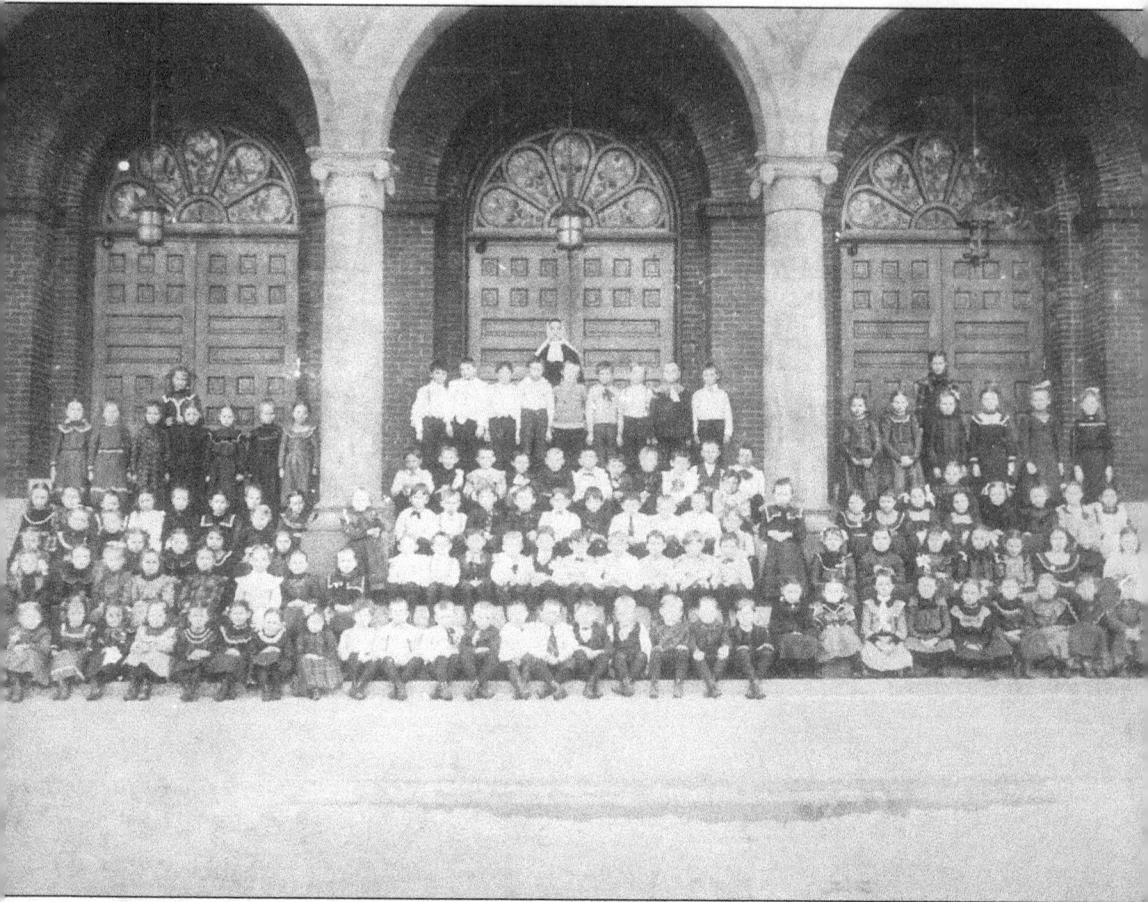

Shown in both of these photographs are two of the oldest extant pictures of students under the care of St. Stanislaus Parish.

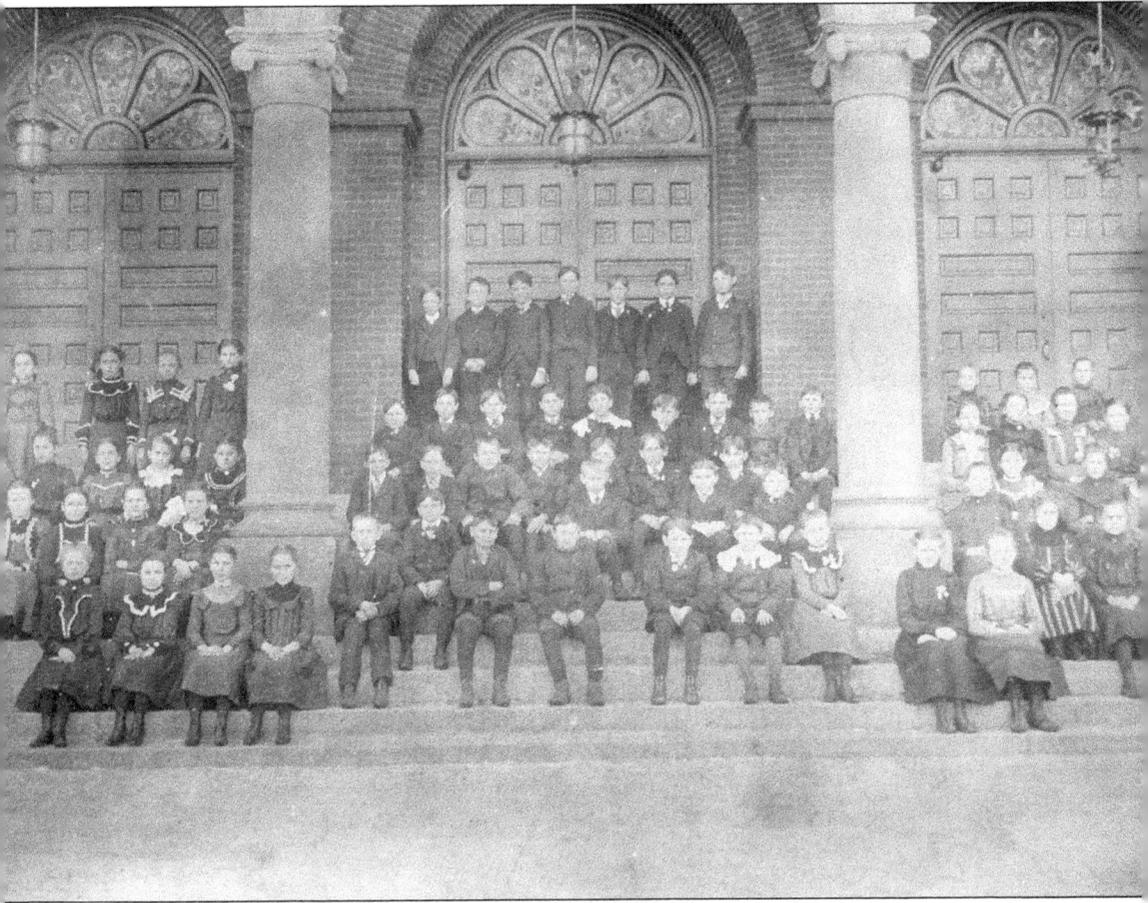

This is a postcard picture of St. Stan's grade 111.

Seen below are graduates of the Old Koszciusko School, located on the northwest corner of Sanborn and Chatfield Streets. Pictured, from left to right, are as follows: (front row) unidentified, Red Przybilski, unidentified, Leona Donahue, (?) Rompa, Leo Craig, and Angie Edel; (second row) (?) Jackson, Helen Fabich, unidentified, John Fabich, unidentified, Clarence Troke, (?) Rosinski, unidentified, and Verna Dettinger; (top row) Verna Dettinger, unidentified, Robert Kleizck, unidentified, Leo Donahue, William Eichendorf, Sylvia Wissen, two unidentified graduates, Rose Kulas, Syl Kukowski, three unidentified graduates, and (?) Myrzek; (top row center) Miss Johannes, teacher.

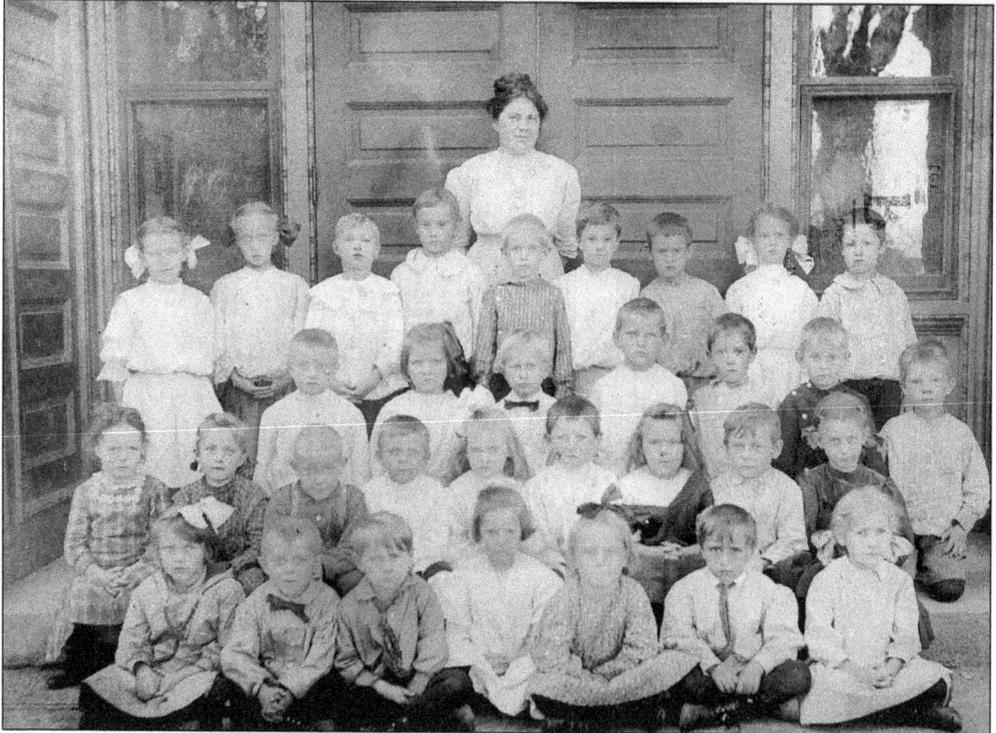

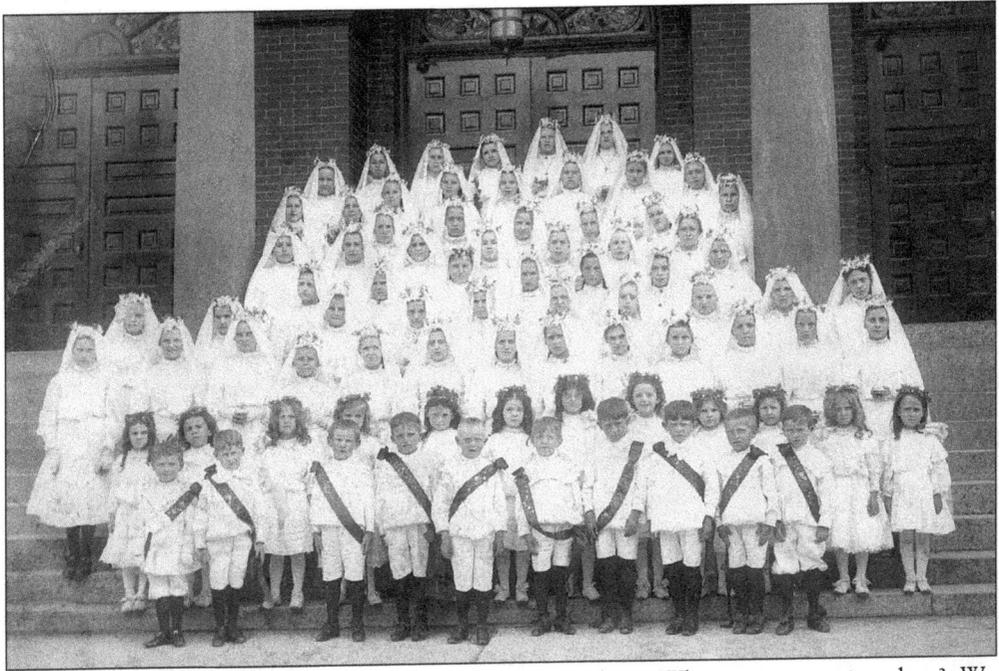

Is this a photo of First Communion? Why the sashes? What year was it taken? We may never know.

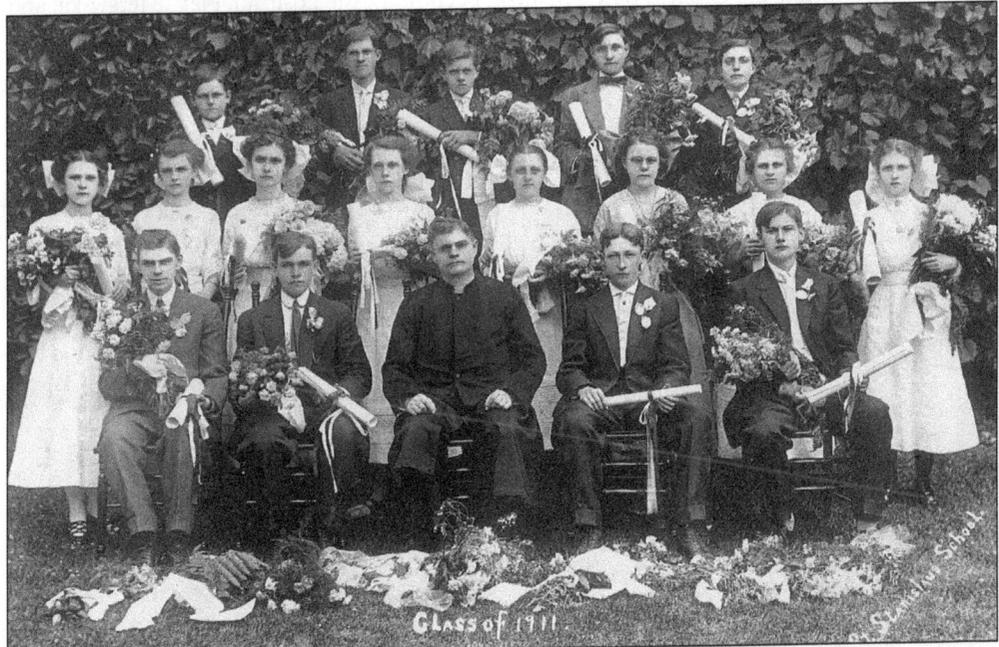

St. Stanislaus School, class of 1911, is seen here. Pictured, from left to right, are as follows: (front row) J. Hamerski, (?) Roblicki, Msgr. James Pacholski, Leon Perszyk, and Joseph Fischer; (second row) J. Grabowski, Eugenia Watkowski Jacobson, Adelaide Jezewski Jaszewski, J. Poblocki, (?) Langowski, J. Meyer, Effie Herek Gernes, and Agnes Lewinski (Sr. Pauline Agnes, C.P.); (top row) Ed Sadowski, J. Grupa, and three unidentified students..

Winona Senior High School class pictures of Winona's finest Polish young ladies, c. 1914: (clockwise, beginning upper left) Francis Sikorski Pecholt, Bessie Losinski, Nettie Jezewska, and Joanna Sikorska Farrington.

More of Winona Senior High School's finest Polish young ladies, c. 1914: (clockwise, beginning from upper photo) Esther Fischer, Stella Beranek, and Irene Fischer.

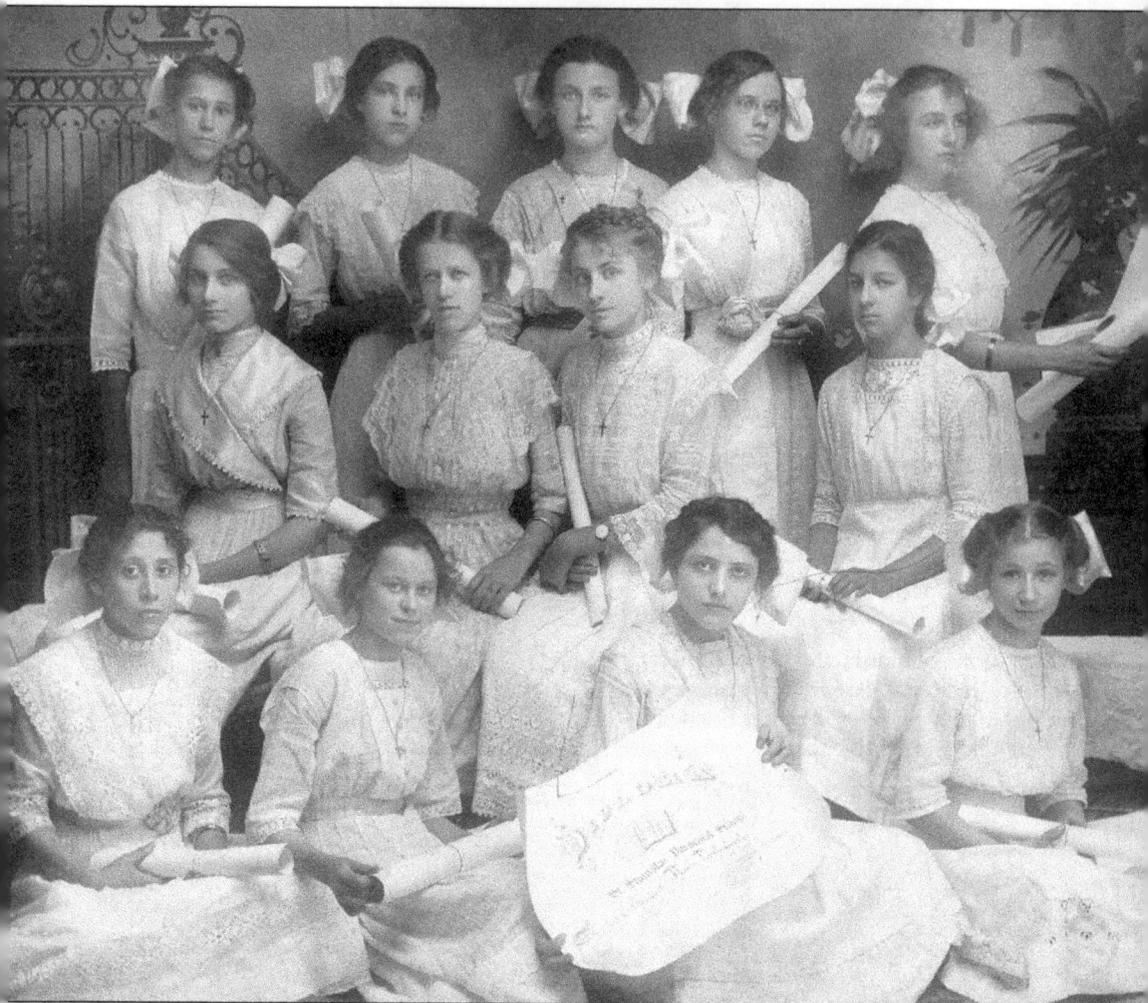

Members of the 1912 graduating class of St. Stanislaus School, from left to right, are as follows: (front row) Millie Wieczorek, Josephine Kowalewski, Tecla Trzebiatowski, and Esther Jereczek; (second row) Agnew Mlynczak, Angeline Potratz, Natalie Jezewski, and Pelagia Prondzinski; (top row) Mary Hering, Pauline Kujak, Frances Fischer, Helen Gabrych, and Estelle Krus.

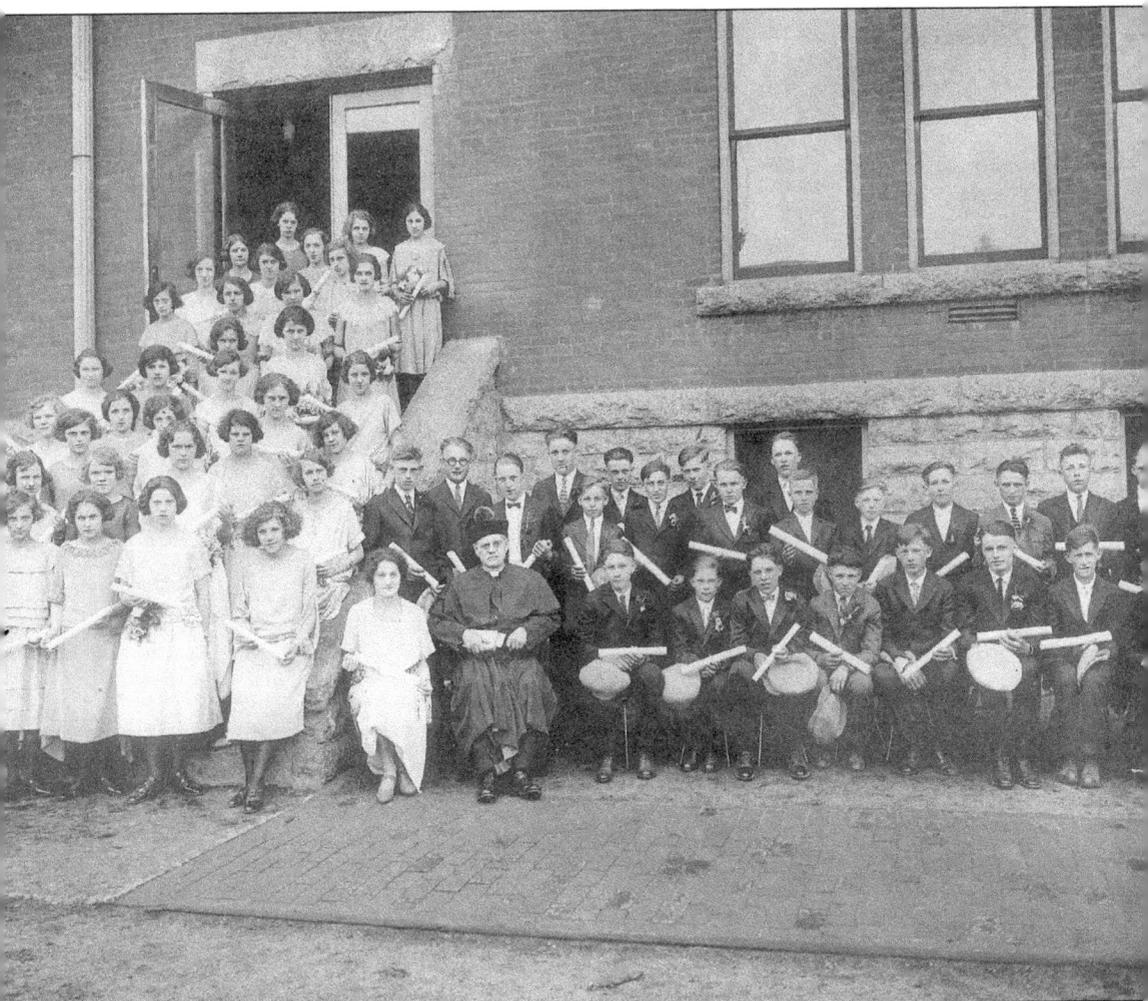

St. Stanislaus Grade School class of 1923 is seen here. Pictured, from left to right on the right-hand side of photo, are as follows: (seated) Msgr. James W. Pacholski, Joseph Podjaski, Steve Sadowski, (?) Sedel, Frank Heftman, Lenoard Konkel, Harry Muras, Vince Zmuda, and Ed Stanislawski; (standing) Harry Kulas, Frank Schultz, Hubert Kukowski, Nicephore Grulkowski, Henry Stanislawski, Joe Kierlin, Henry Speck, Joe Janikowski, Romuald Potratz, Henry Feltz, Frank Hamerski, Louis Paszkiewicz, Harry Kowalczyk, Stanley Kamroski, and Frank Knopick. Girls pictured on the left-hand side of photo in no particular order, are as follows: Edwina Kukowski, Elizabeth Watembach, (?) Wnuk, Sally Czaplewski, Marie Dahm, Dolores Kukowski, Sally Rosinski, Sarah Wnuk, Agnes Winiecki, Esther Edel, Anna Rosinski, Mary Styba, Mary Bronk, Leona Lukaszewski, Rose Wieczorek, Betty Sulla, Emilia Wnuk, Mansueta Glubka, Florence Knopik, Mary Pehler, Dorothy Walski, Gert Sadowski, (?) Lilla, Valeria Kiedrowski, Agnes Kluzik, Mary Anglewicz, Anna Kulas, Eltruda Piechowski, Josephine Cisewski, Eleanor Styba, Leona Cholewinski, Ceil Jereczek, Harriet Bynczik, and Irene Sulla. Identification provided by Harriet Bynczik.

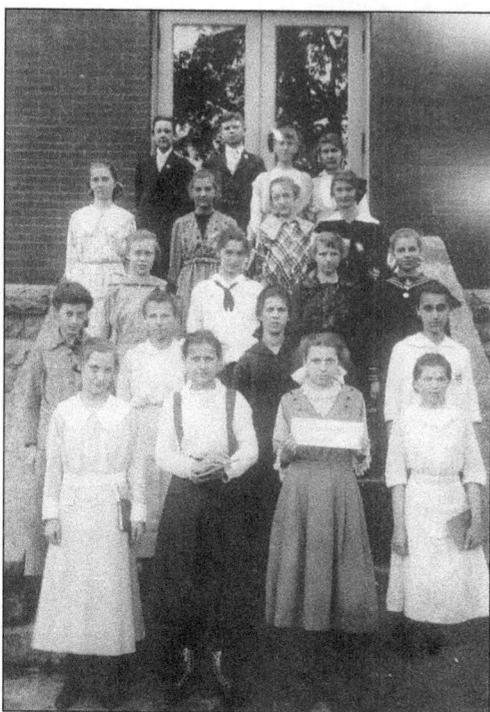

The St. Stanislaus School class of 1916, from left to right, are as follows: (front row) Margaret Jereczek, Victoria Gostomski, Julia Sieracki, and Helen Ritter; (second row) Ann Liberko, Helen Czaplewski, Julia Prondzinski, and Frances Stoltman; (third row) Blanche Rosinski, Hermie Jereczek, Theodosia Knopick, and Gertrude Sikorski; (fourth row) Helen Wilma, Henrietta Watkowski, Isabelle Perszyk, and Effie Watkowski; (top row) Sylvester D.J. Bruski, Edward Myszka, Frances Wyrdych, and Sally Sieracki.

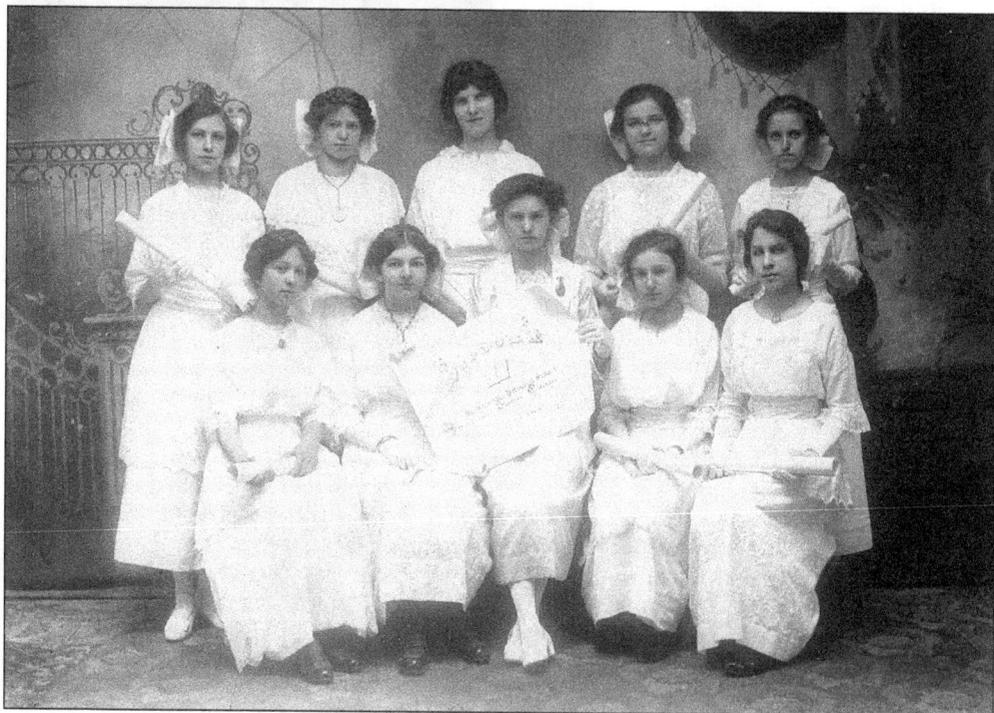

The St. Stanislaus class of 1914, from left to right, are as follows: (front row) Ann Prondzinski, Mansuetta Watkowski, Florence Cierzan, Celia Dudzinska, and Frances Nowicki; (top row) Gertrude Lince, Veronika Ramczykowska, Seraphine Weir, Stanislawa Bambenek, and Frances Rozek. Photo donated by Mansuetta Watkowski.

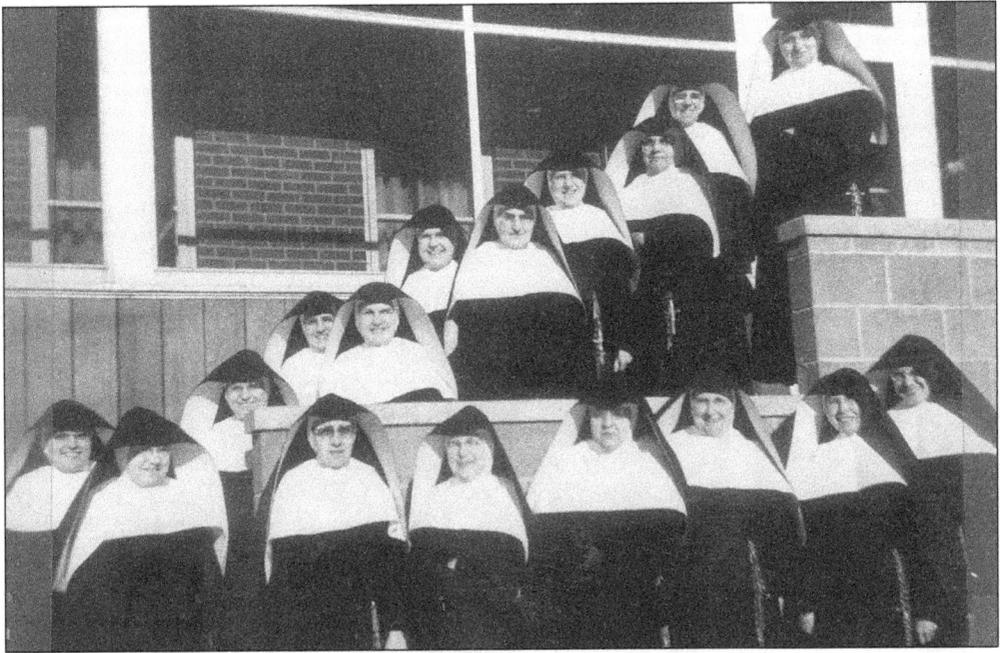

The nuns in this photo, from left to right, are as follows: (front row) S.M. Minette, S.M. Joanice, S. Mary Edward, S.M. Columba, S.M. Florine, S.M. Lydia, S.M. Priscilla, and S.M. Aldure; (second row) S.M. Giovanni and S.M. Lolanda; (stairway) S.M. Alphonsine, S.M. Hedwiges, S.M. Victoria, S.M. Francita, S.M. Ladislas, S.M. Anthonita, and S.M. Florian. This photograph was taken prior to March 25, 1963.

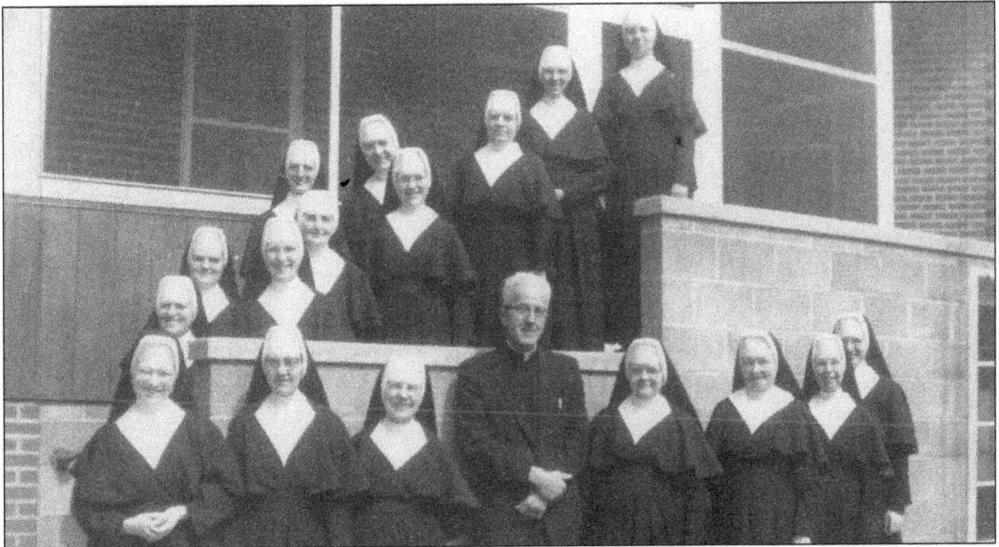

Pictured here is St. Stan's Notre Dame Sisters' change of habit. From left to right, they are as follows: (front row) S.M. Janice, S. Mary Edward, S.M. Columba, Msgr. Grulkowski, S.M. Florine, S.M. Lydia, S.M. Priscilla, and S.M. Aldure; (second row) S.M. Giovanni, S.M. Lolanda, and S.M. Minette; (stairway) S.M. Alphonsine, S.M. Hedwiges, S.M. Victoria, S.M. Francita, S.M. Ladislas, S.M. Anthonita, and S.M. Florian. This photograph was taken after March 25, 1963.

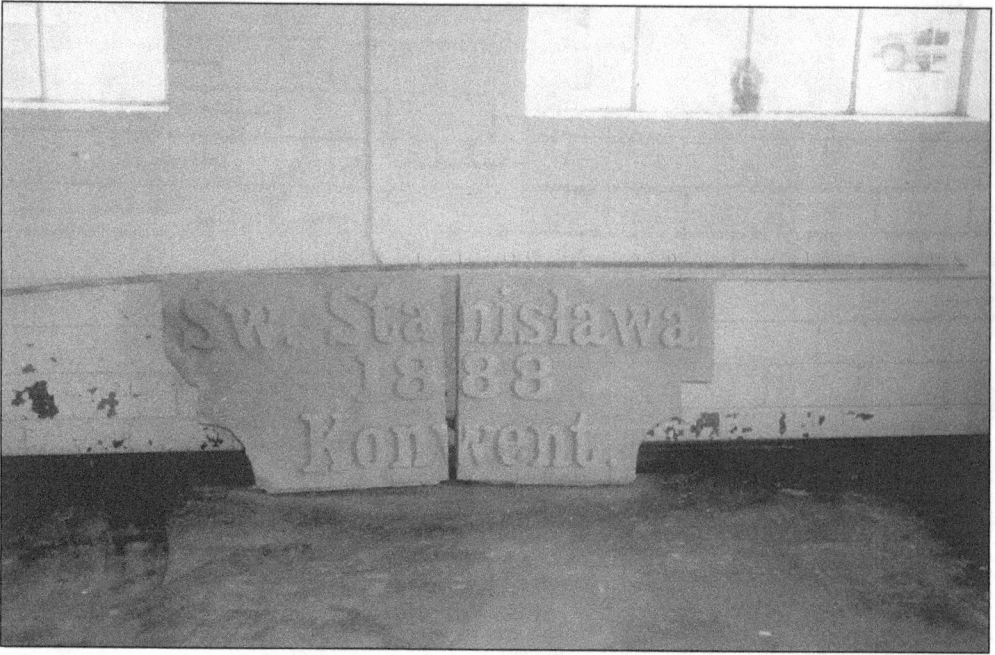

School Sisters of Notre Dame taught parish children in kindergarten through eighth grade. The convent was located adjacent to the church and across the alley from the school. It was demolished in the early 1990s.

Notre Dame Sisters are seen here: Sr. Vincenta (left) and Sr. Arnoldine, organist at St. Stan's.

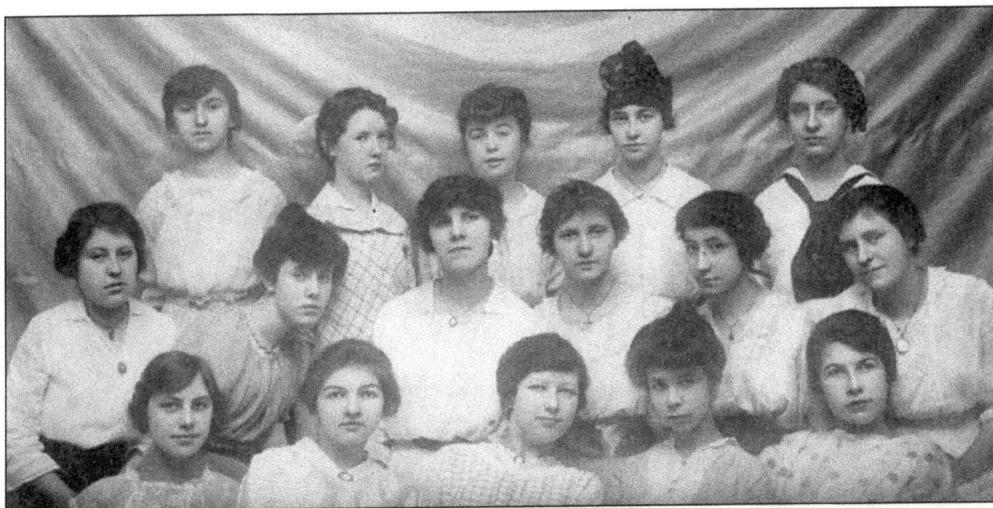

Seen here is the 1914 freshman class of Cathedral High School, Winona. Pictured, from left to right, are as follows: (front row) Gertrude Lince, Mary Watkowski, Ethel Dooney, and two unidentified students; (second row) two more unidentified students, Sarah Weir, unidentified, Frances Nowicki, and unidentified; (top row) Ceil Duginski, Irene Galagher, two unidentified students, and Margaret Steffes.

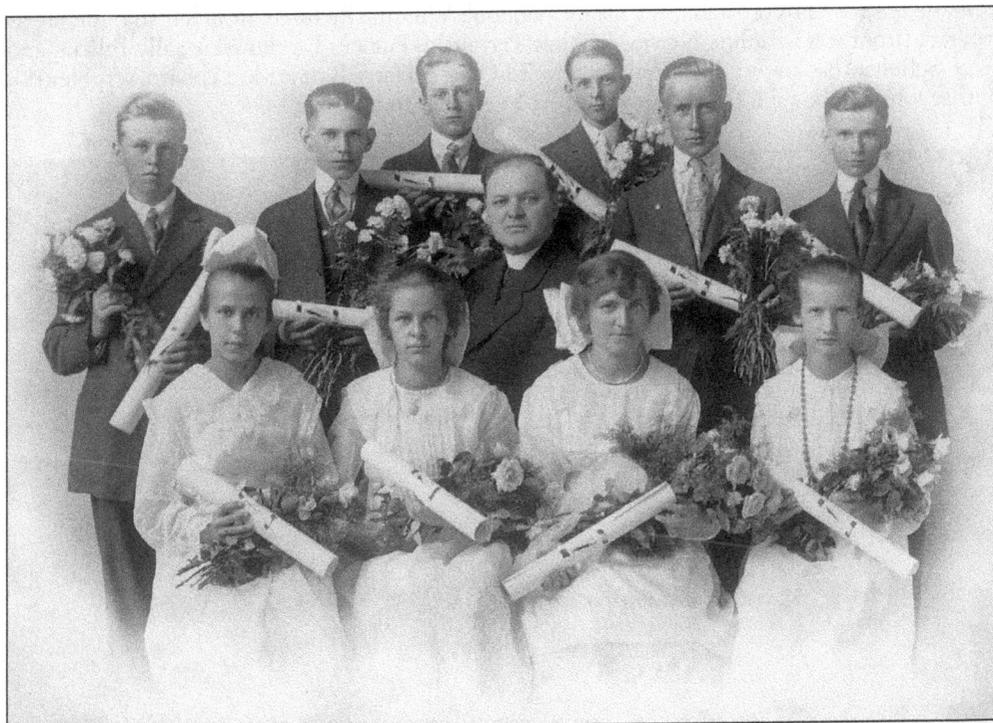

The class of 1917, St. Casimir's School, Winona, from left to right, are as follows: (front row) Dora Dorsch (Sister Josaphat, SSND), Myrtle Walczak (Mrs. Marion Kluzik), Monica "Mae" Franckowiak (Mrs. Leo Borkowski), and Agnes Bilicki (Mrs. Wilbert Smith); (top row) Joseph Newman, Zigmund Jaszewski, Jowh Stroinski, Theodore Wiczek, Mieczyslaw "Mae" Barankiewicz, and Frank Wesolowski.

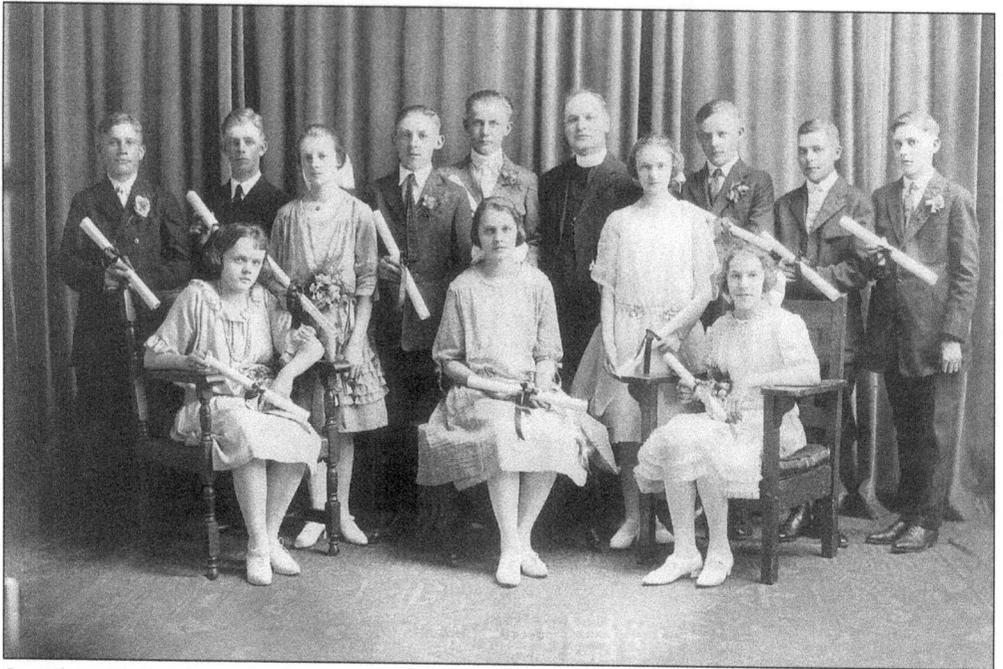

Seen here is the class of 1925, St. Casimir's School, Winona. Pictured, from left to right, are as follows: (front row) Pauline Newman, Alice Przytarski, Frances Drazkowski, Sally Bilicki, and Rose Schultz; (back row) Al Stroinski, Edward Chuck, Harry Ratajczyk, Leonard Wroblewski, Father John Grabowski, Barnie Newman, Al Mosiniak, and Claude Mason.

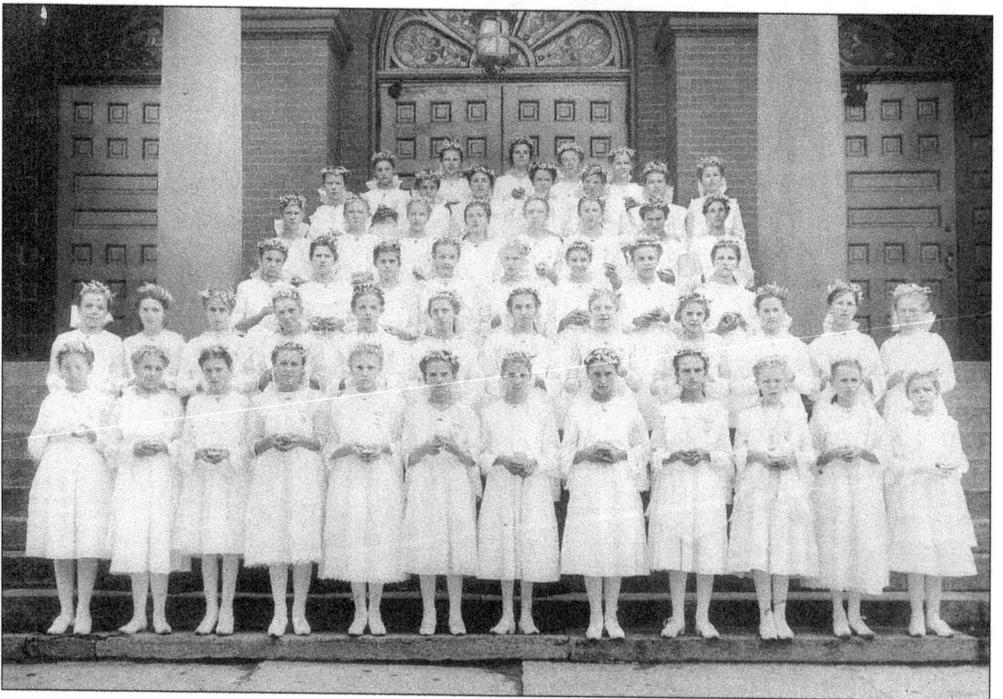

This is a photo of a First Communion class of St. Stanislaus Church.

Eight

WEDDINGS

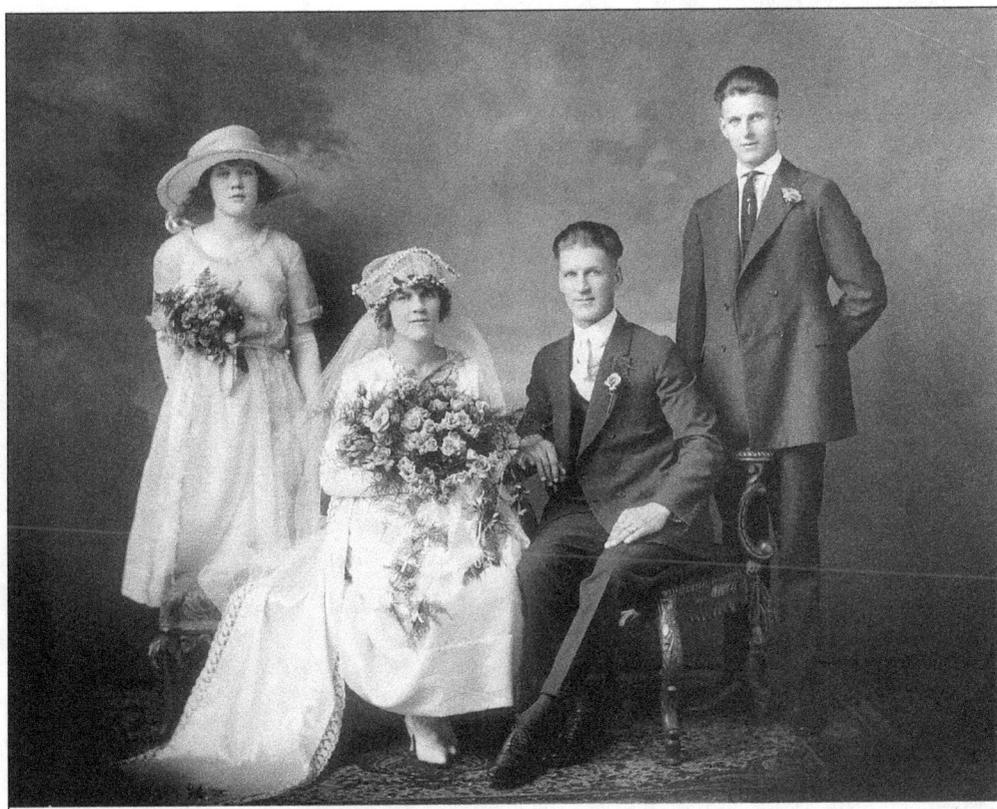

This is a wedding photo of Josephine Scharmach and Vince Breza. Joe Breza and Romelle Scharmach are present as attendants.

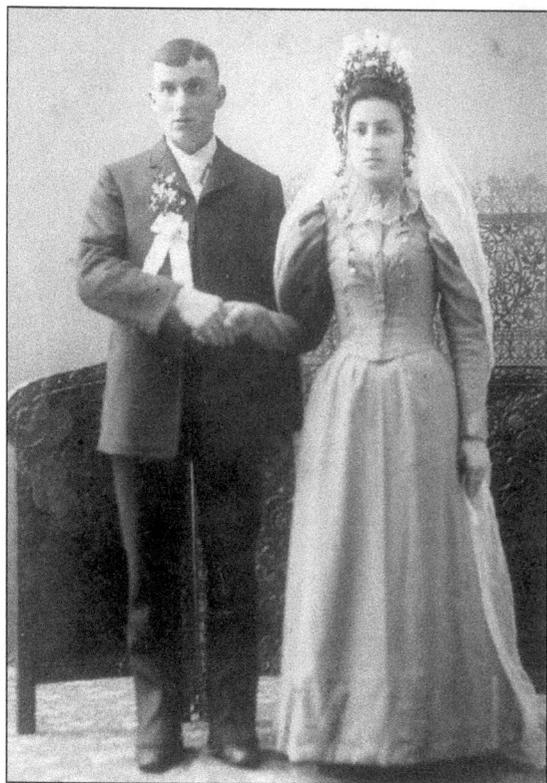

Jacob Wieczorek and Mary Cierzan Wieczorek were married at the church of St. Stanislaus Kostka in 1894.

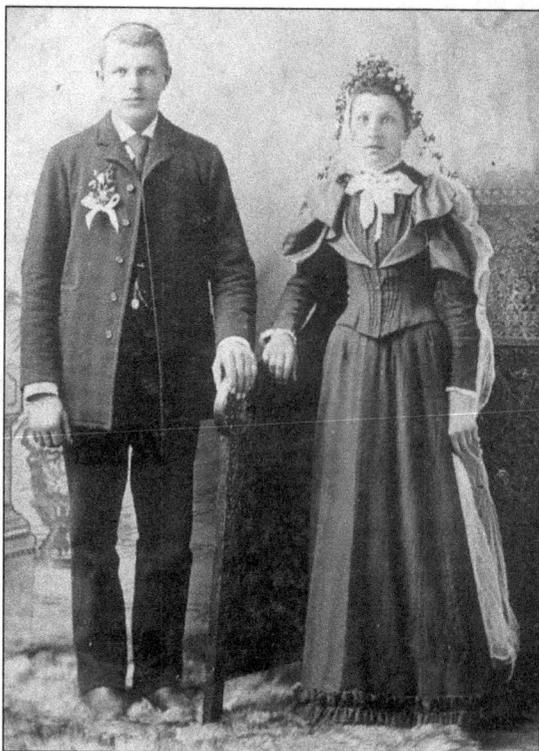

This is a wedding photo of an unidentified Polish couple. Note the white floral head-dresses in both photos. Typical white wedding dresses were not common until after 1900.

Pictured here are Mr. and Mrs. Hieronim Derdowski. Mr. Derdowski was publisher of the *Wiarus*, a Polish newspaper produced in Winona.

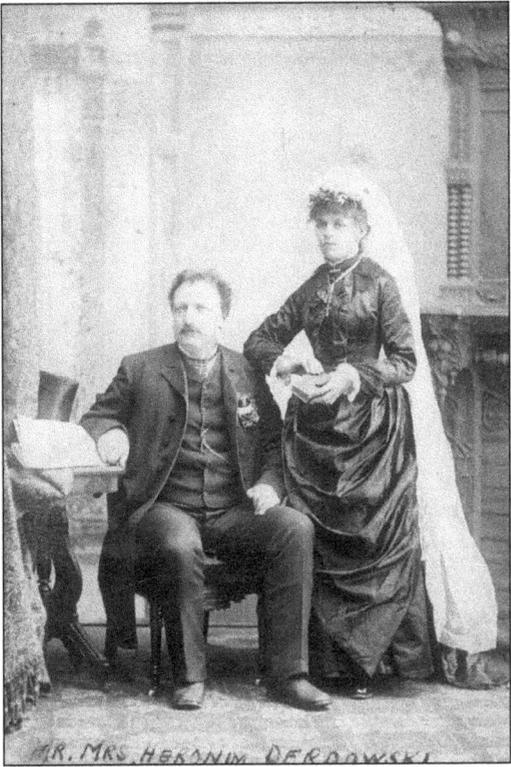

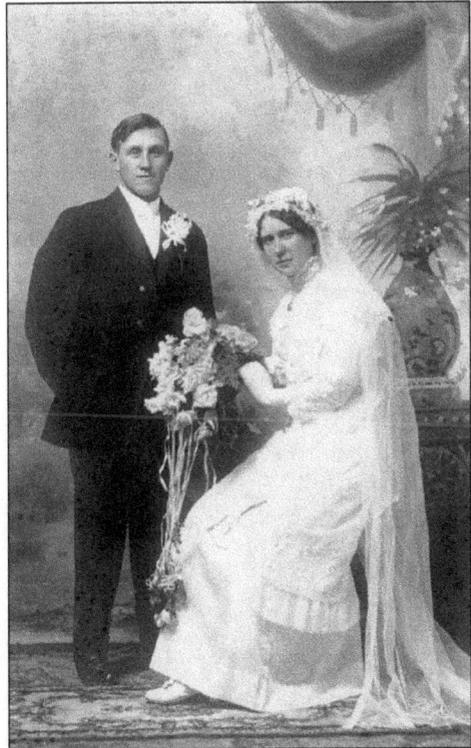

Mr. and Mrs. Joe Prondzinski are seen here.

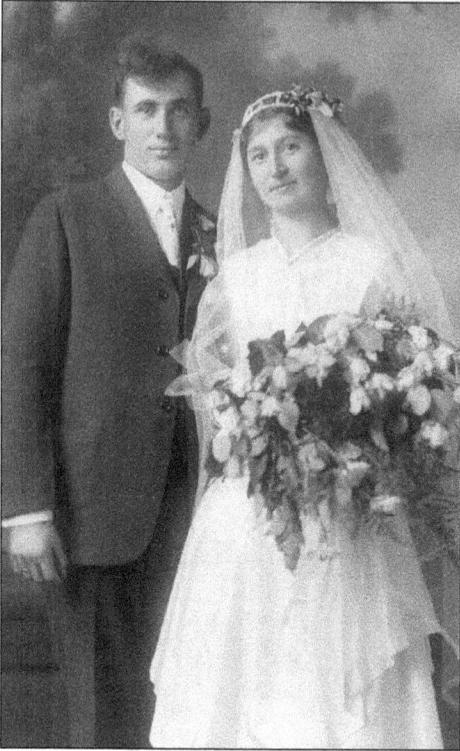

This is a wedding photo of Mr. and Mrs. Kaiser (Julia Glowczewski).

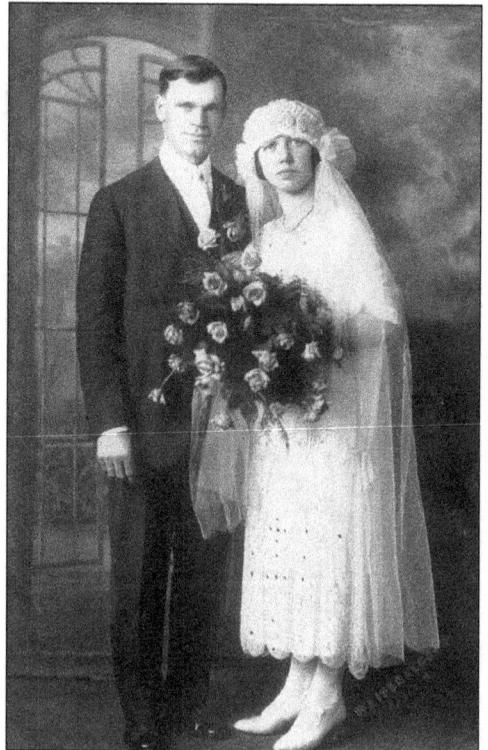

This wedding photo was taken of Mr. and Mrs. Martin D. Pellowski of Dodge, Wisconsin.

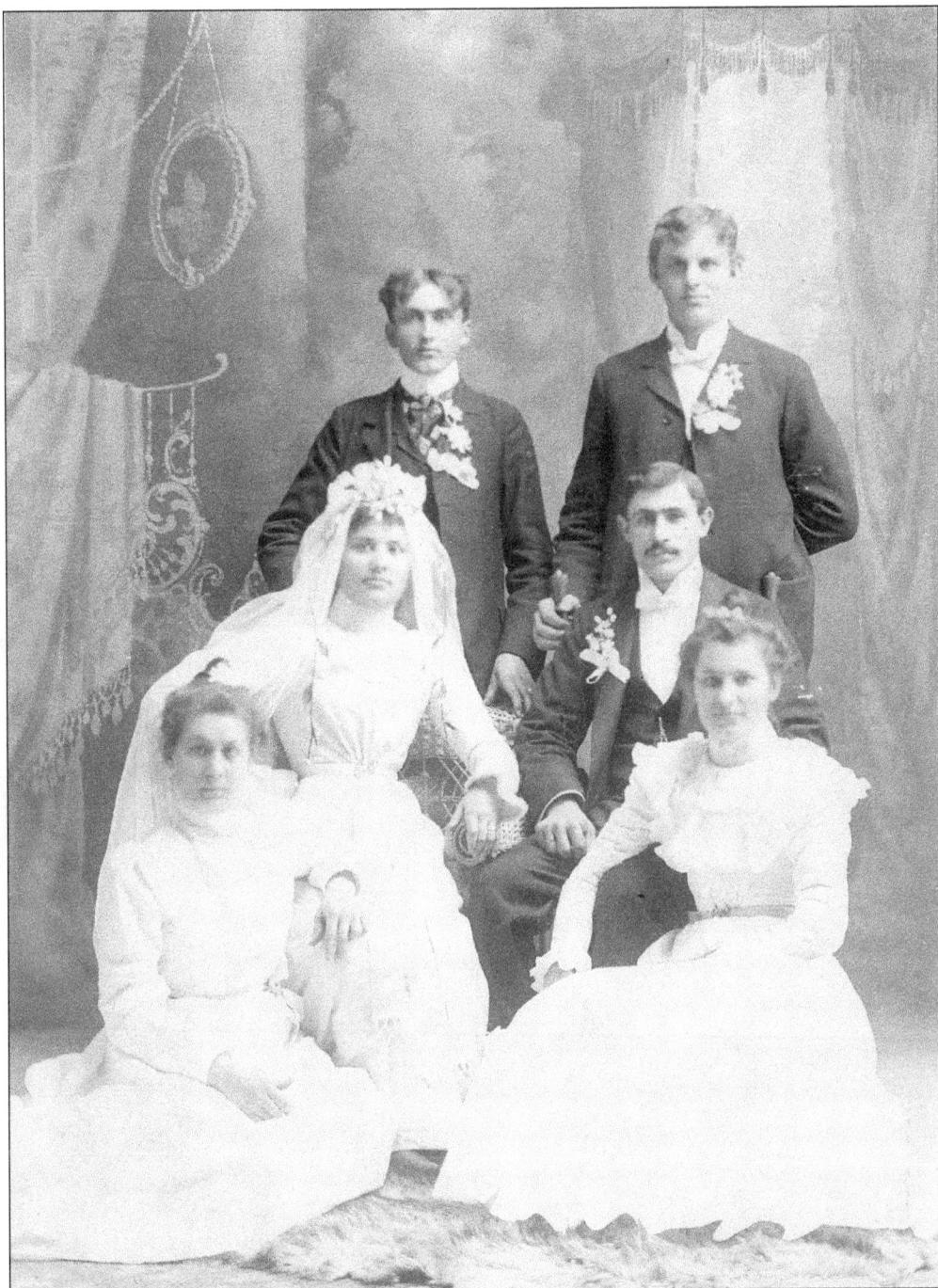

Seen here is the wedding picture of Robert Cierzan and Johanna Wicka Cierzan. Pictured, from left to right, are as follows: (front row) Augusta Wieczorek Verkins and Frances Wicka; (top row) Felix Wicka and Martin Brom. The Wicka family had settled in nearby Trempealeau County across the Mississippi River from Winona—one of many families of Polish descent who had family ties with Winonans of Polish descent. Almost all early Winona-area Poles came from northwestern Poland, an area known as Pomerania or Kashubia.

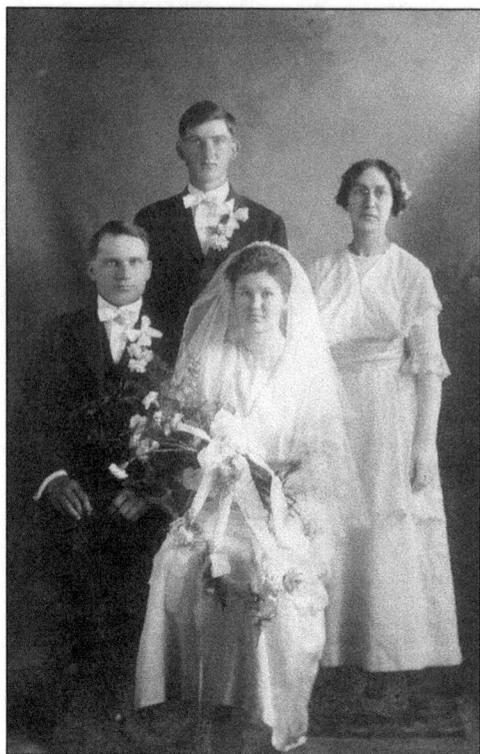

Joe and Victoria Omburada are seen here.

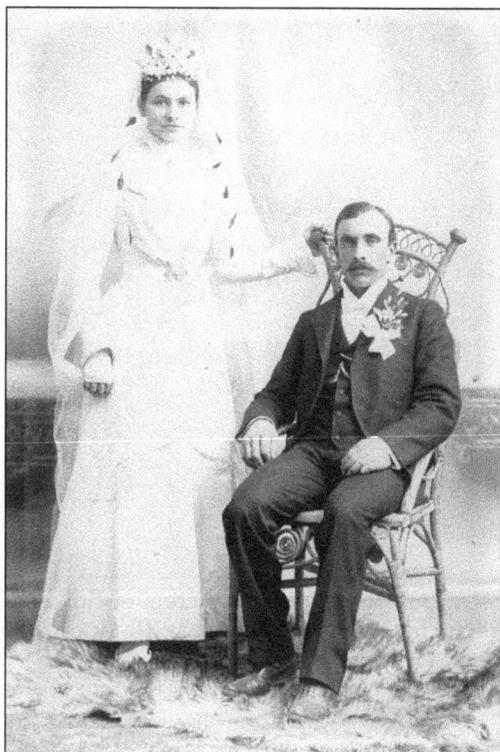

Michael and Josephine (Kulas)
Wieczorek are seen here.

Nine

FAMILIES

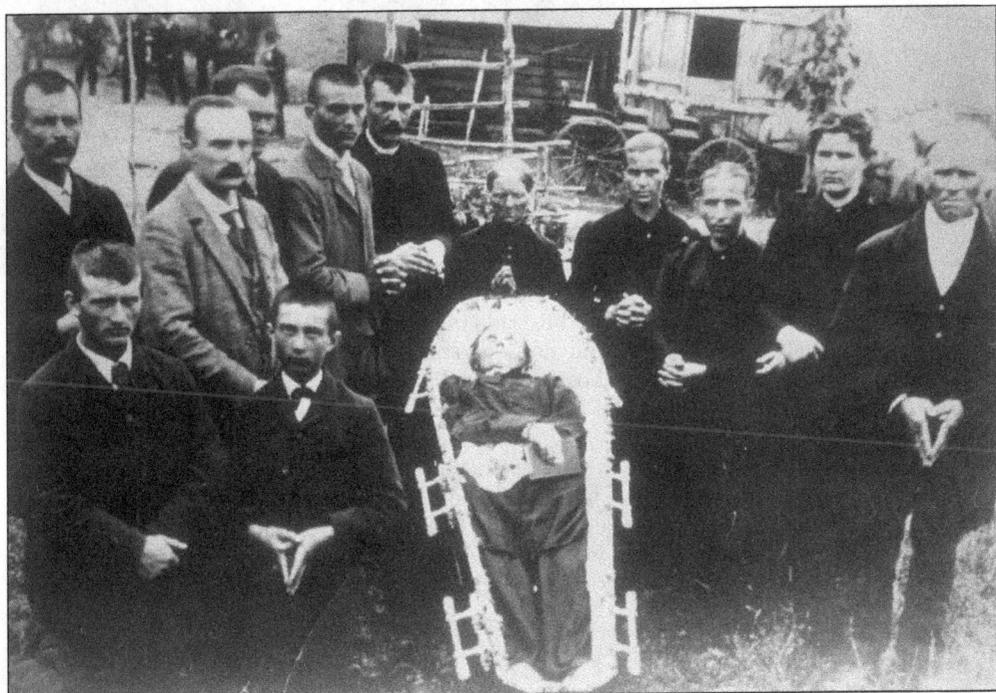

The Losinski family is seen here in Poland. They were attending the funeral of great-grandfather Pastwa.

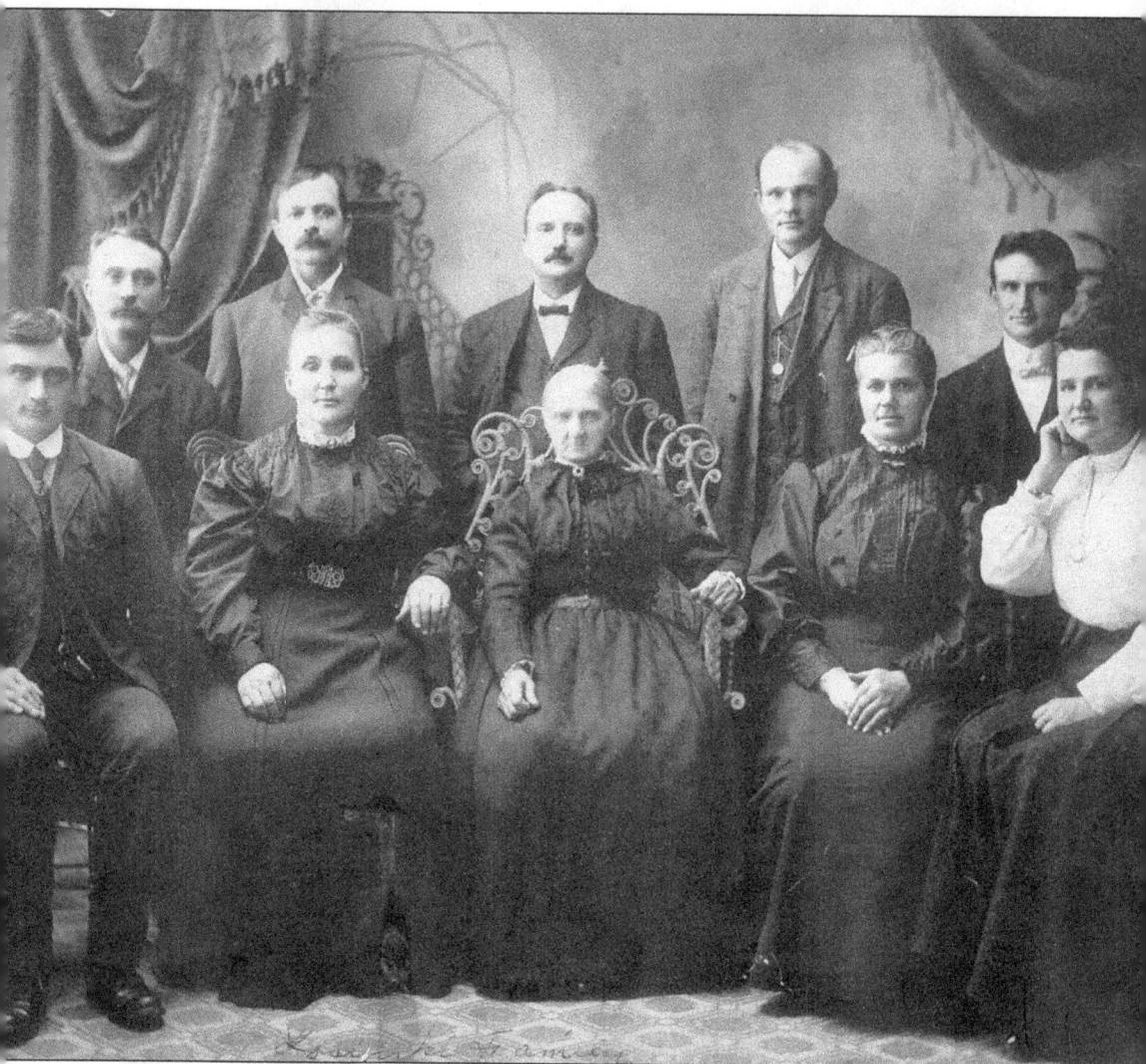

The Losinski family is pictured here. From left to right, the family members are as follows: (front row) John Losinski, Justine Losinski Rogalla (who died in 1918), Pauline Pastwa Losinski (great-grandmother), Julia Losinski, and Polly Losinski; (top row) Joseph Losinski, Andrew Losinski, Jacob Losinski, Maximilian Losinski, and Leo Losinski. Justine (Mrs. Jacob Rogalla) was the mother of Agnes Rogalla (Mrs. Ted Bambenek), who was the mother of Jim, Ted, and Maxine Bambenek.

The history of the Rogalla women is as follows: Angeline never married; Agnes married Theodore (Ted) Bambenek Sr.; Minnie married Harry Bambenek; Josephine married Jack Warsinski; Jenny married John Wlodarczyk of Owatonna, Minnesota; Blanche married John Rackow of Owatonna; Helen married Frank Breza; and Lucy married Ed Sikorski. This photograph is dated c. 1890. It was donated to the Polish Cultural Institute by Irene (Mrs. Mose) Bambenek.

Veronica Pehler came from Bytow, Poland, with her mother Mary (Peplinski) (Bojan) Jaszdzewski at age three. She helped boat passengers who were sickly and was involved in health care through much of her life. She was widowed at an early age. She was able to raise eight children to adulthood.

Lawrence Bronk was one of the first Polish settlers in Winona.

The Pehler girls are seen here. From left to right, they are as follows: Lilian Larson, Mary Kulas, Alice Breza, and Selma Kratch.

These are the Bambenek sisters. The Bambenek name was one of the earliest to be found in Winona. The family originated in Kashubia, in the northwestern part of Poland, abutting the Baltic Sea.

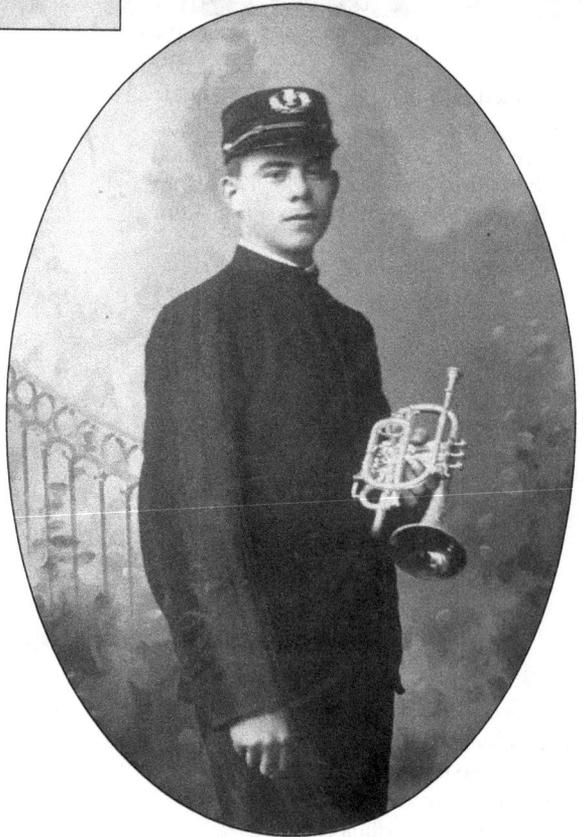

Max Cieminski is seen here.

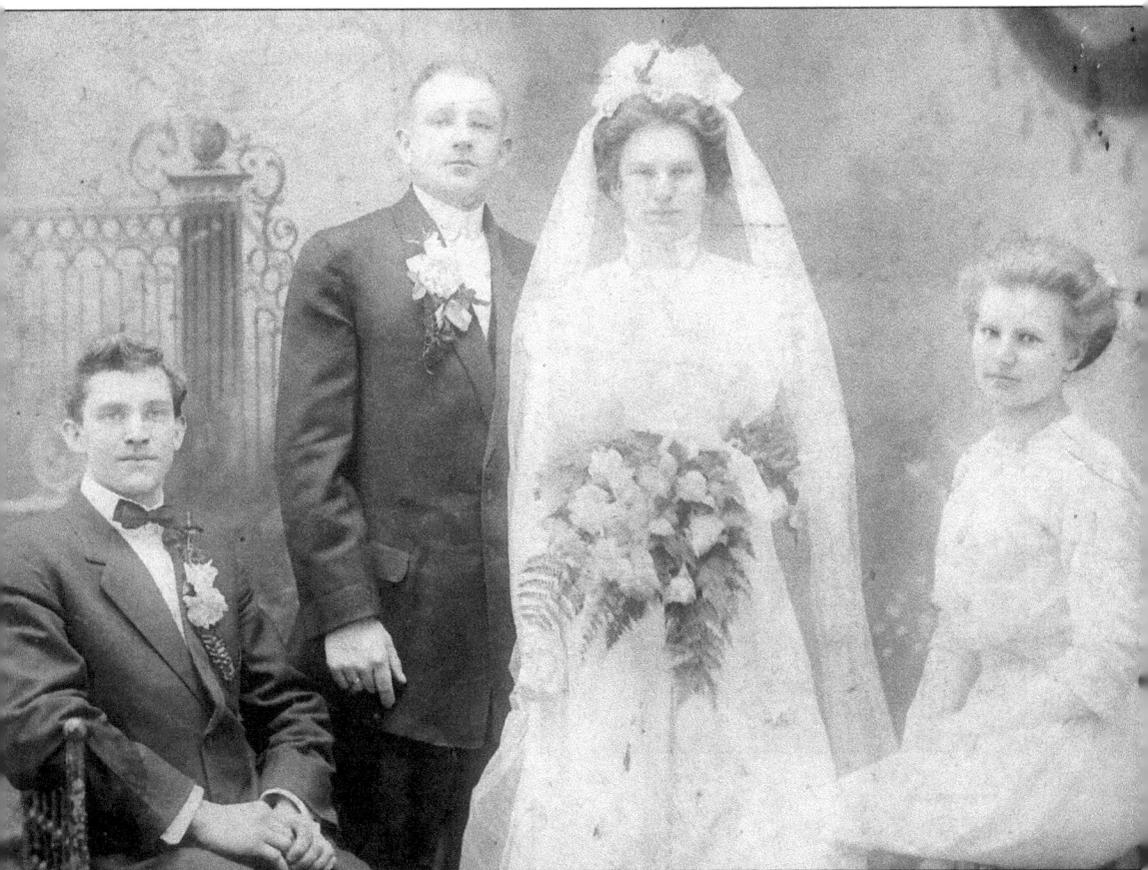

Pictured, from left to right, are as follows: Joe Kaczorowski, Victor Malewicki, Kate Kaczorowski Malewicki, and Blanche Malewicki.

Frankie Kiedrowski was known as "Gee Gee's husband."

This is the First Communion photo of Frances Galewski.

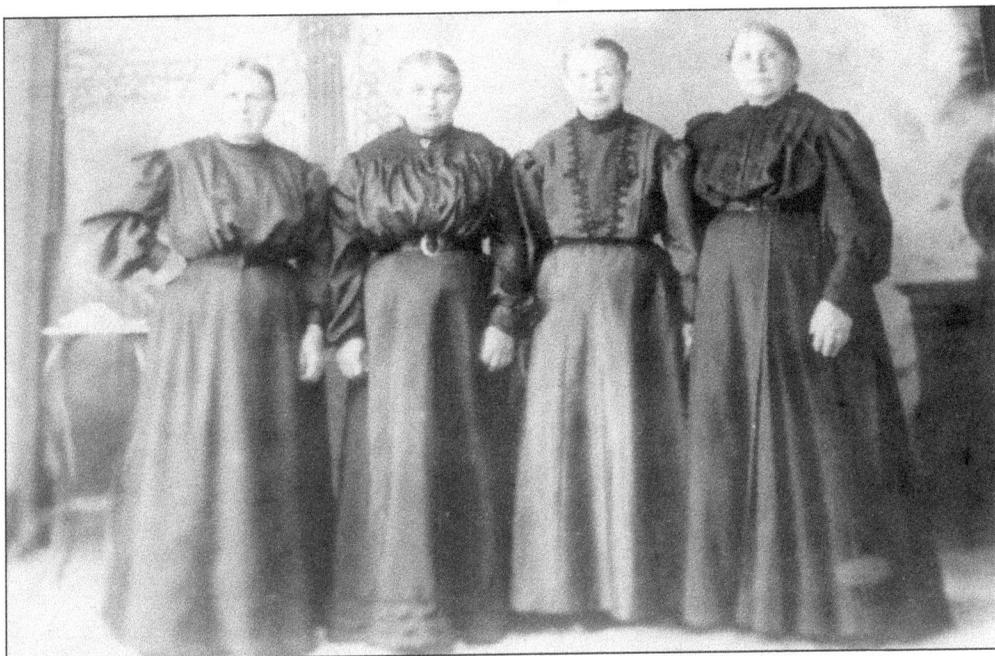

Pictured, from left to right, are as follows: Mrs. Cisewski, Mrs. Peter (Mary) Kulas, Mrs. Martin (Magdalen) Galewski, and Mrs. Literski, of Pine Creek and Dodge, Wisconsin

Frances Breza poses here with two "lunkers." Frances (Hering) Breza rowed a boat to Marshland and back. Baby (Joe), wrapped in a blanket, was wedged in the prow of the boat. Drums from the Indian settlement could be heard while fishing.

Seen here is another fishing picture. Note the long narrow strip boats that were made in Winona, and that were also the pride of anyone able to own one of them. These boats could be rowed in a straight line with just one oar because of their pointed bow and deep pointed keel. Rowing with one oar enabled a single person to fish while continually moving the boat to new spots rather than waiting for the fish to come to the boat.

Pictured here are two postcards from Pelagia
Repinski to her sister Theodosia Prondzinski.
This first one, top, shows the statue of poet
H. Derdowski, with his brother standing beside
it. The second one, below, shows an old wooden
church in Derdowski's area of Wiele.

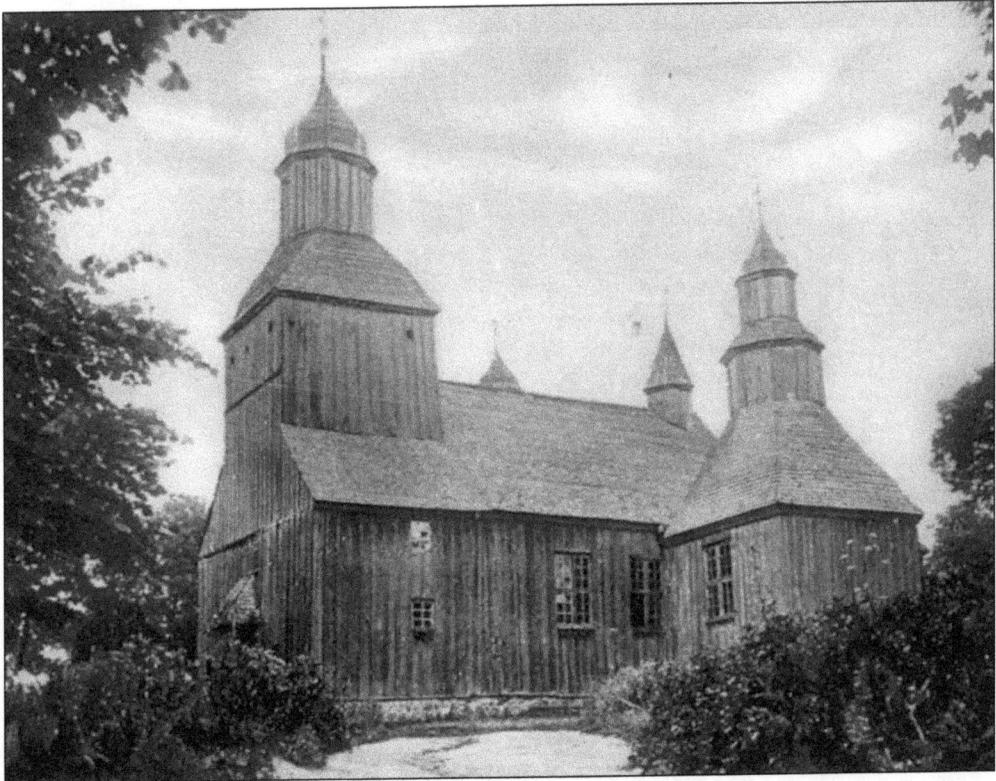

This is a picture of "Rose" Joswick.

Anton Cierzan, seen here, was the father of Mary Cierzan Wieczorek and Frank L. Cierzan.

Ambrose Glowczewski is photographed here in Arcadia, Wisconsin.

Jacob Michalowski is at the reins of this surrey with the fringe on top in Winona, Minnesota. The team of horses was his and he was taking his wife, Mary (Kosobucki) Michalowski, his three sisters, and a visitor for a ride in the country in the early 1890s. Left to right, they are: Companion nun, Anna (Michalowski) Benedict, Sr. M. Catherine, Sr. M. Modesta, Jacob Michalowski, and Mary (Kosobucki) Michalowski.

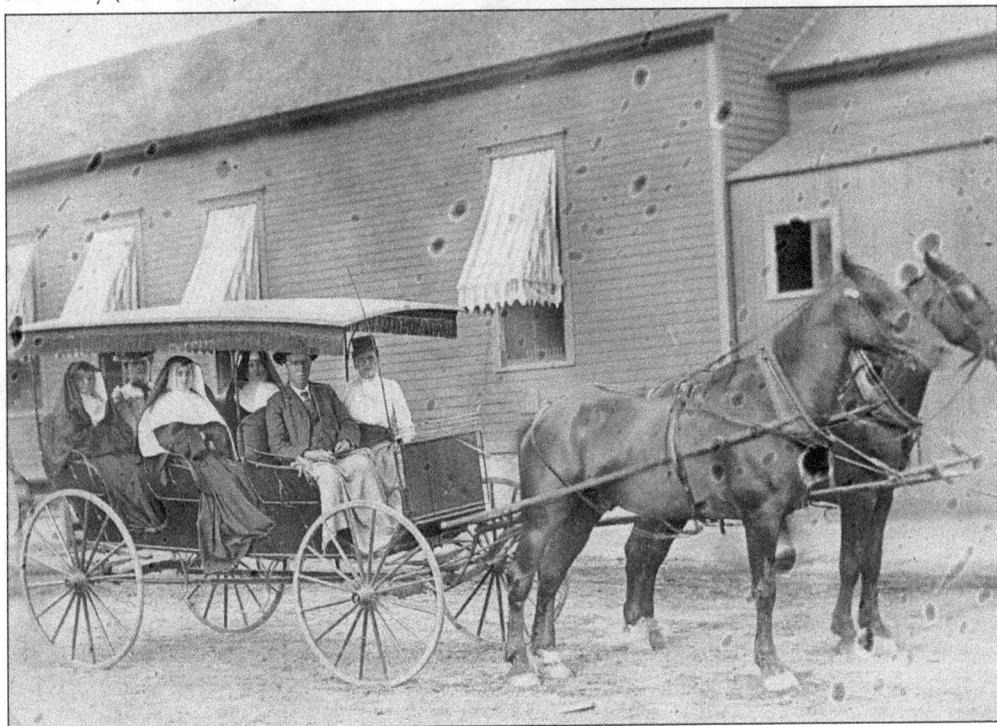

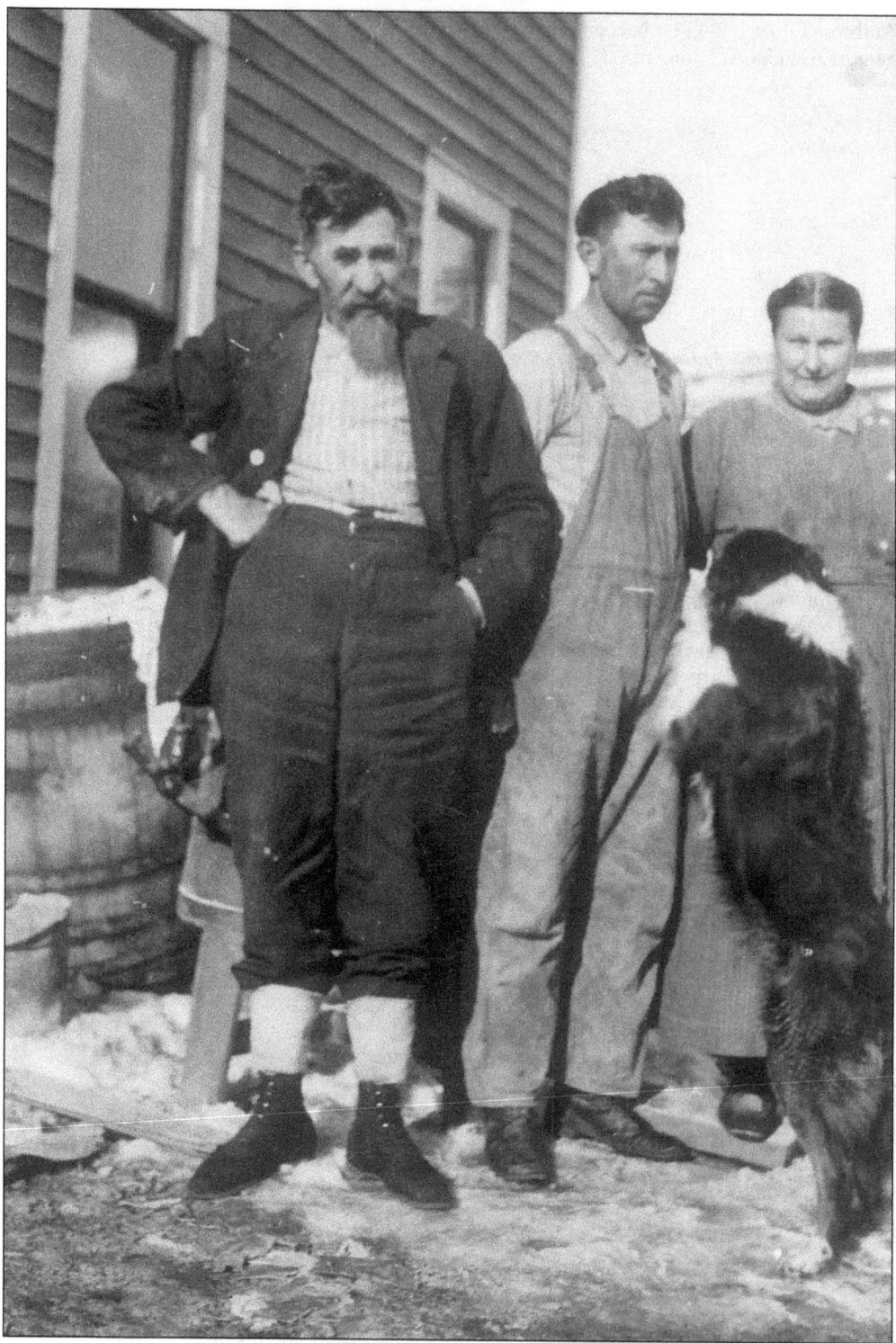

Pictured, from left to right, are as follows: John Glowczewski, Joe Glowczewski, Frances Breza, and Sport, the dog, in Rainey Valley, Arcadia.

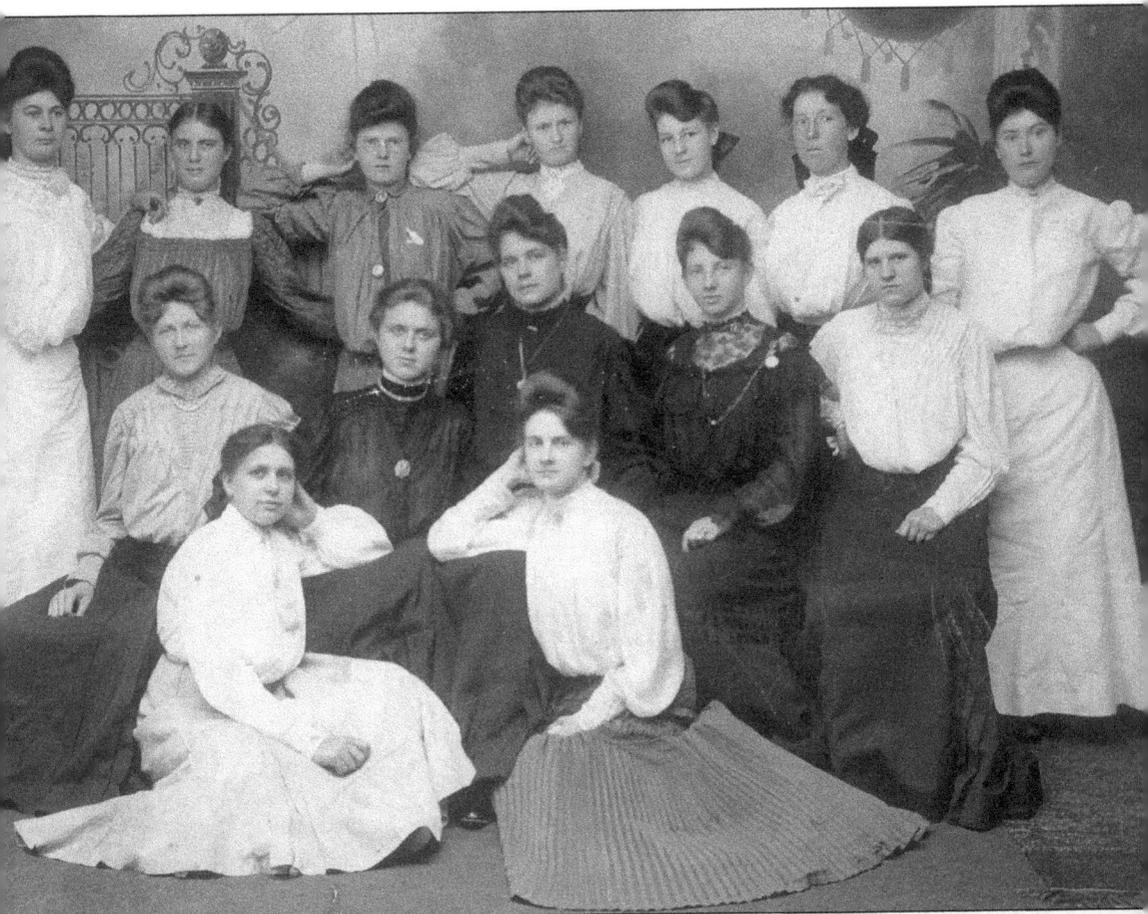

The only information available on this photograph is: "Wroblewski, 750 West Fifth Street, Winona, Minnesota."

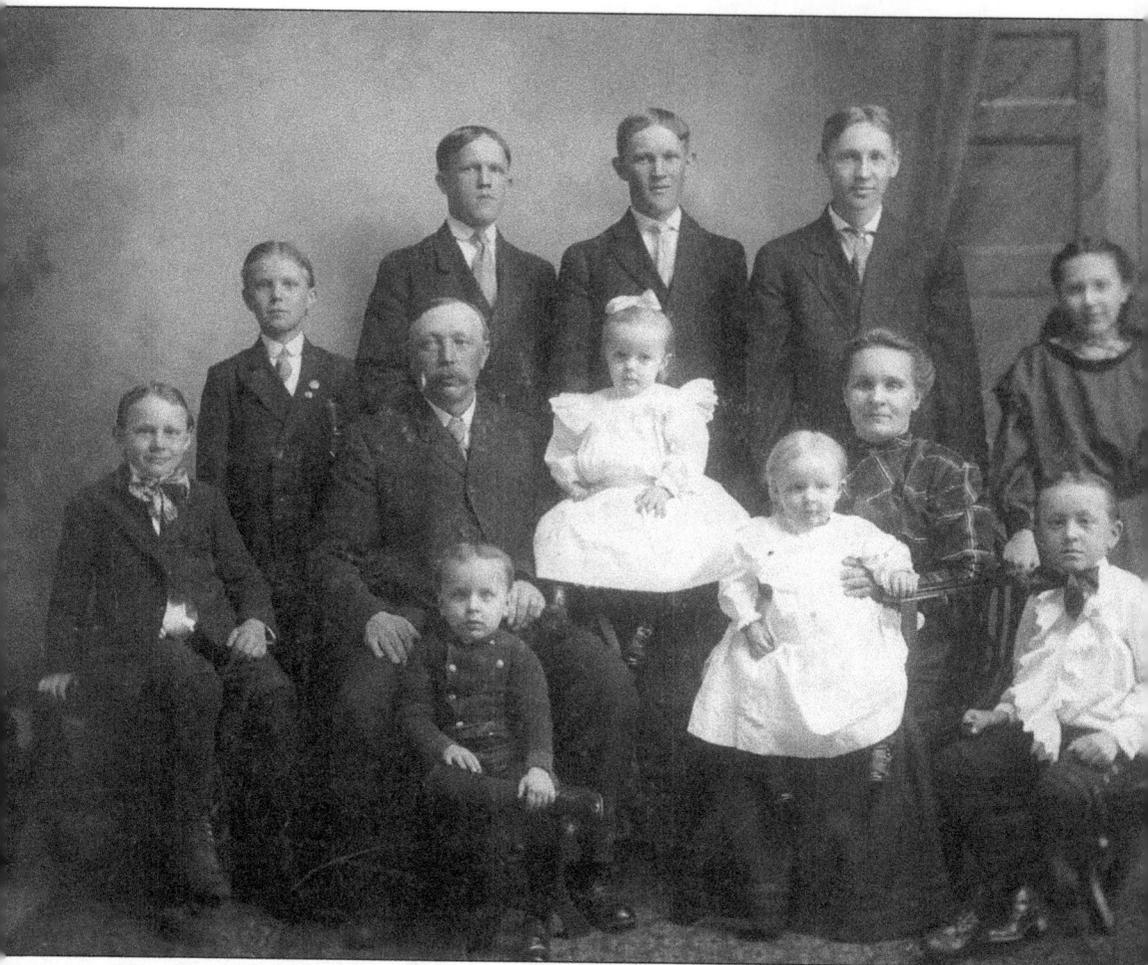

The John Newman family is photographed here. Sister Florine, S.S.N.D, is pictured as the baby in the center. Sophia is on her mother's lap, Stella on the far right, and Barney (with bow tie). Brother Polycarp is seated in front of his father. Sister Florine was the principal at St. Stanislaus School in the late 1940s and early 1950s.

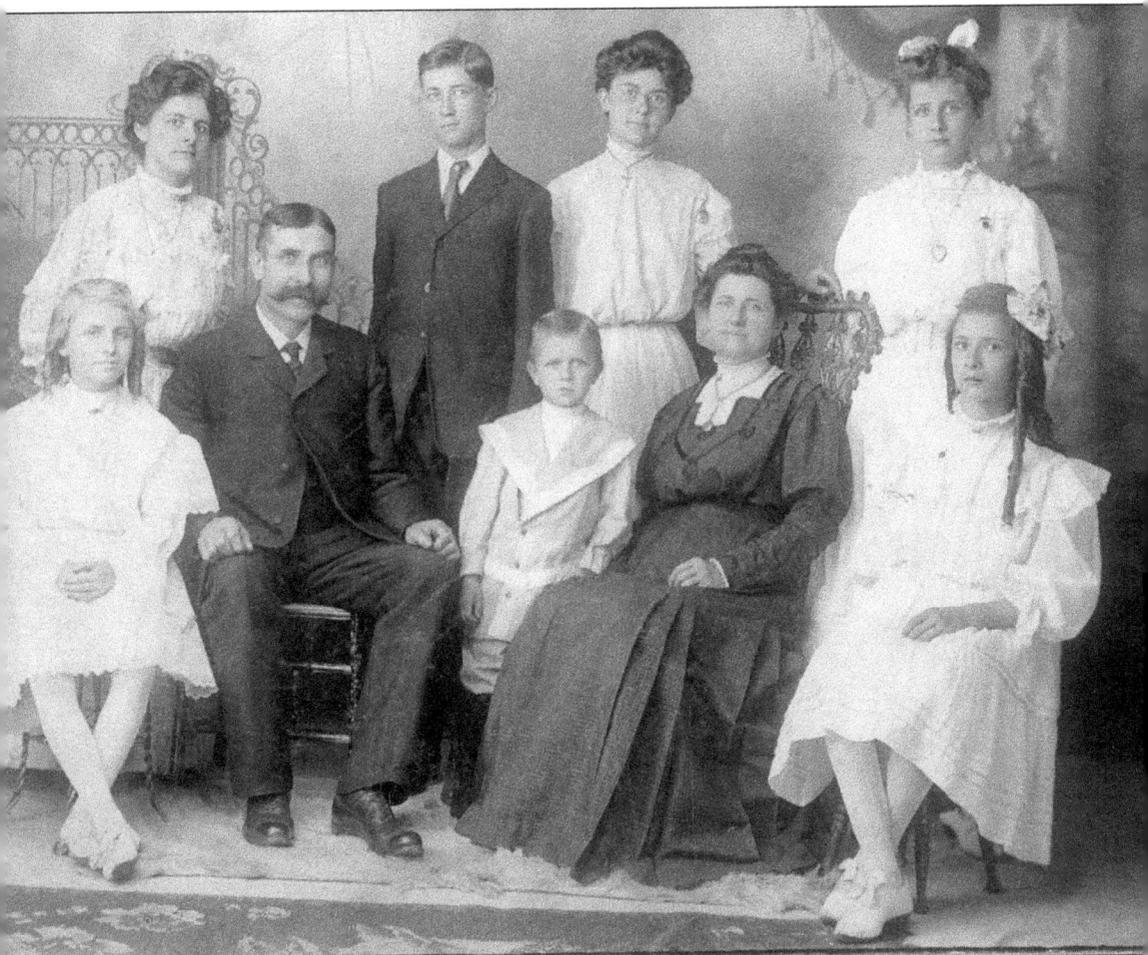

Members of the Andrew Jezewski family, from left to right, are as follows: (front row) Natalie Jezewski Verdick, Andrew Jezewski, Henry Jezewski, Apolonia Jazdzewski Jezewski, and Adelaide Jezewski Jaszewski; (top row) Emma Jezewski Kaniewski, John Jezewski, Sister Mary Henry Jezewski, O.F.M., Sylvania, Ohio, and Lillian Jezewski Wiczek.

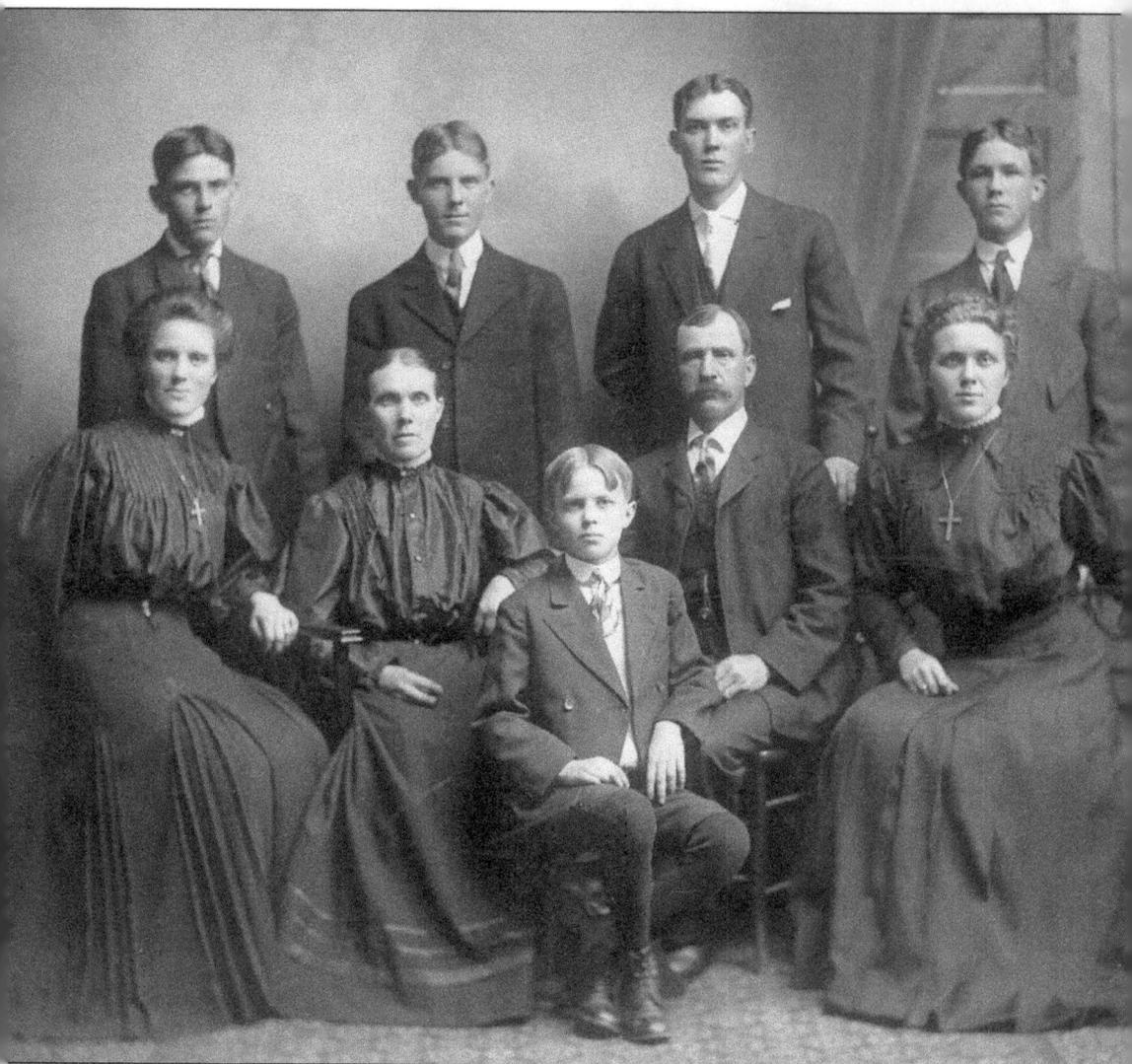

The Joseph Kleinschmidt family, from left to right, is as follows: (center front) Nick; (center row) Stella, Lorraine, and parents Joseph and Anna; (top row) Frank, Anton, Joseph, and Dominic.

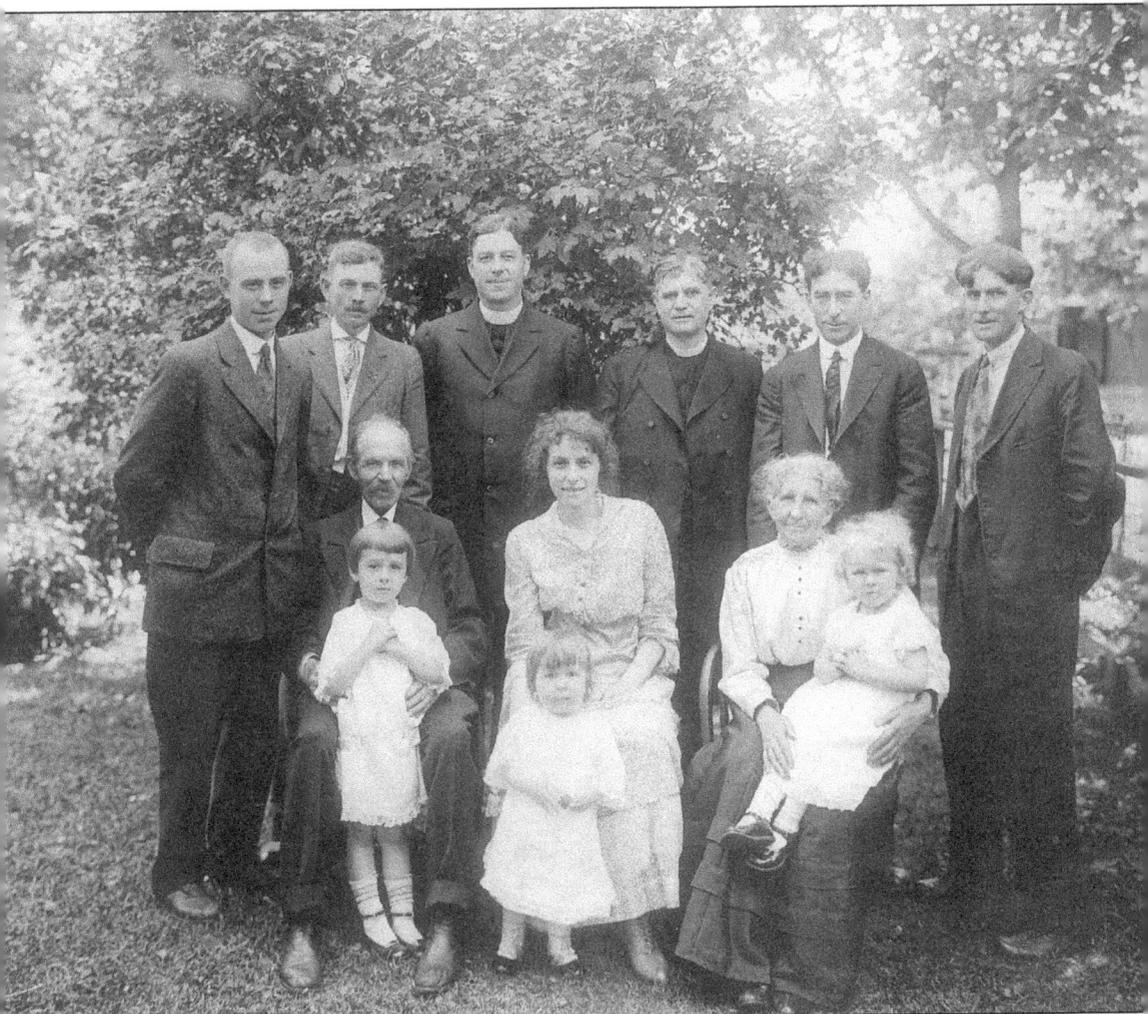

Pictured here is the family of Father Joe Cieminski, pastor at St. Stanislaus Kostka in Winona for many years. He is pictured third from left in back row. Next to him is Father Pacholski, who preceded him as pastor for many years. The family members, from left to right, are as follows: (front row) Dorothy Green, Everetta Green Womack, Josepha Green, and daughters of M.C. Green; (second row) Frank Cieminski (father), Mary Cieminski Green, and Maryanna Cieminski, mother; (top row) Max Cieminski, Vincent Cieminski, Rev. J.F. Cieminski, Rev. J.W. Pacholski, Theophil Cieminski, and Ignatius Cieminski.

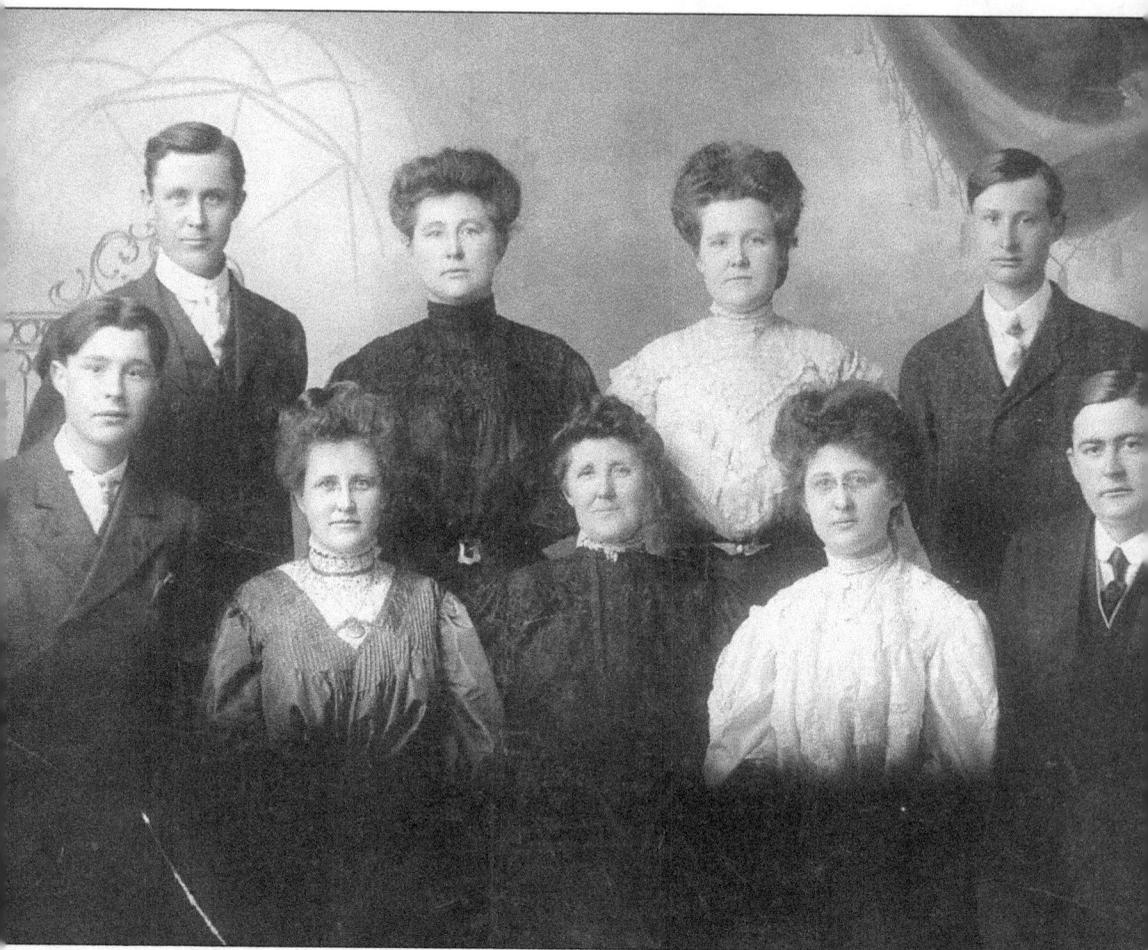

The Cichanowski family, from left to right, is as follows: (front row) Felix, Stella, Maryanna Rybarczyk Cicanowski (mother), Helen, and Joe; (top row) August, Laura (Mrs. Teofil Bambenek), Agnes, and John.

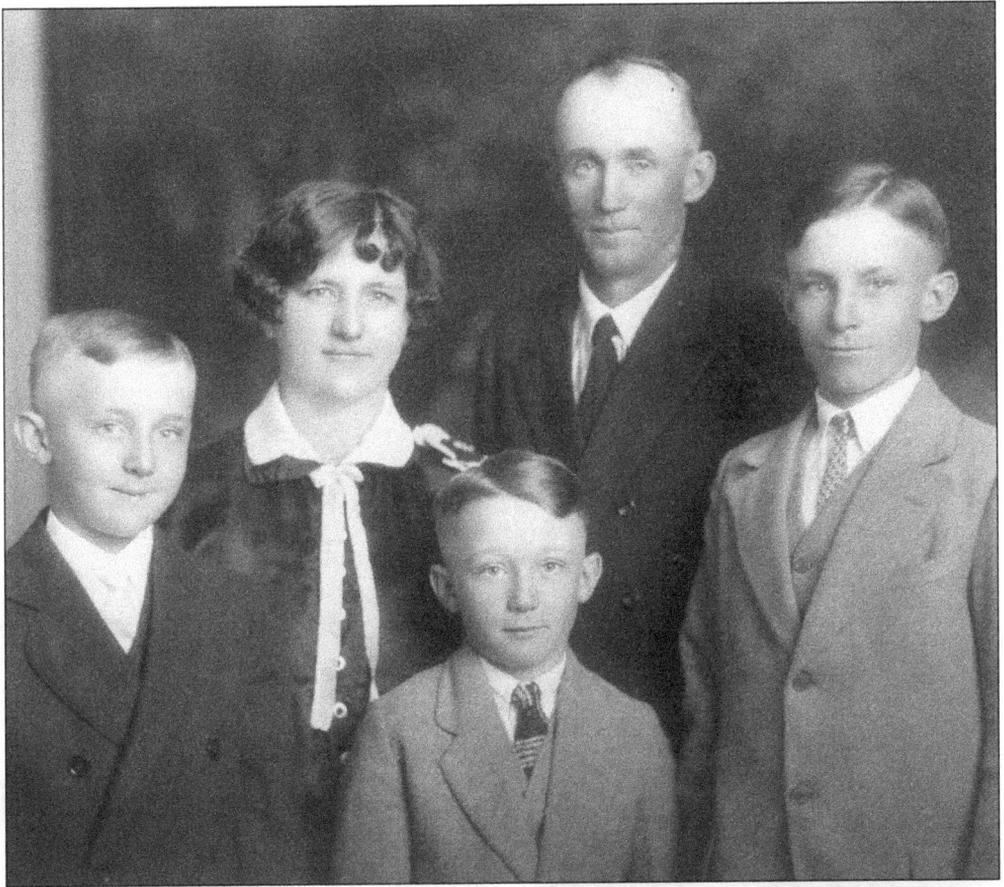

Seen here are Jenny and John Wodarczak and sons (left to right): Stanley, John, and "Hub."

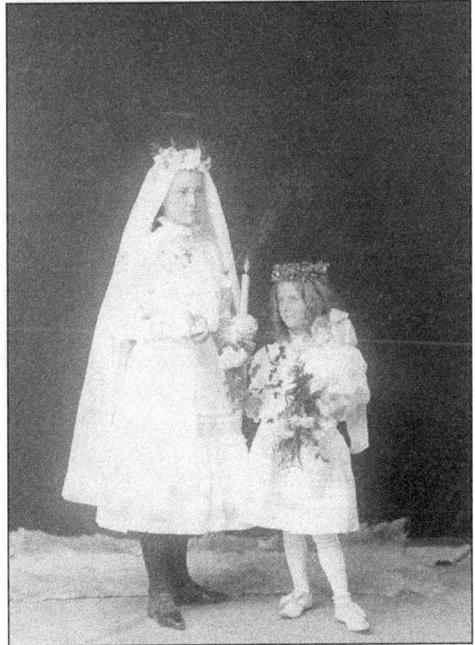

Lucy (Rogalla) Sikorski and Blanche (Rogalla) are seen here.

Agnes Rogalla Bambenek is photographed here.

Clockwise from left, these children are as follows: Dan Bambenek, Mose Bambenek, Harriet (Bambenek) Cierzan, and Raymond Bambenek.

Seen here is Leonard Bruski, born
November 6, 1872, in Lubnie
Powiat, Chojnice, Poland.

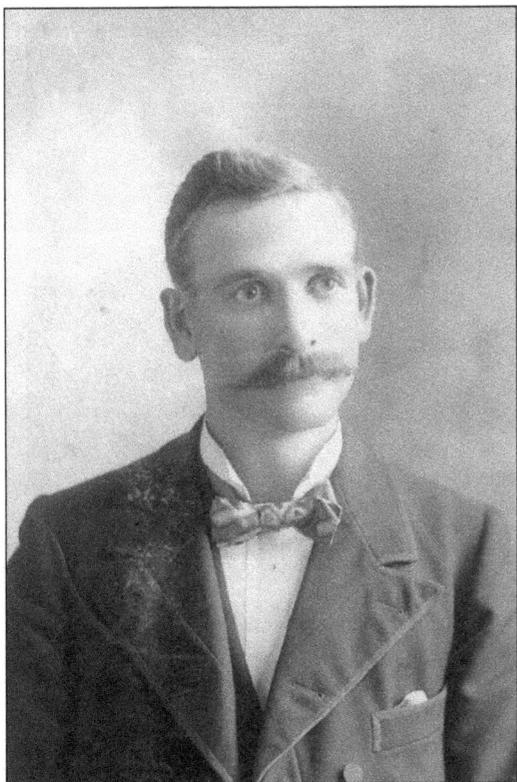

Martin Brom was a prominent
businessman in the Pine
Creek and Dodge area.

John C. Bambenek, Winona's city treasurer, was born on December 13, 1891, and died on October 26, 1966.

Florence Maliszewski, daughter of Vincent and Anastasia Rudnick Maliszewski is seen here.

Ten

SECOND MIGRATION DAUGHTER CITIES

Polish settlements that had their origin in Winona are in Greenbush, Perham, and Browerville in Minnesota; Minto, Warsaw, Jamestown, Scranton, and Beach, North Dakota; and eventually, Wibaux, St. Philip, and Hogeland, Montana.

The Minnesota settlements came first, starting in the 1870s, and progressed west, with Montana's desert area going last, about 1916, with the Stoltman and Olszewski families. "Bad times" in farming in the '20s and '30s caused re-migrations back to the east: Detroit, Minneapolis, and even back to Winona. Some families, however, moved further west, and Winona's Polish Kashubian influence now reaches from Washington all the way to the Ben Pehler family in New Jersey. One hundred and fifty years later, a few have even gone full circle and returned to Poland (Ryan Gostomski) to start new careers in the land of origin.

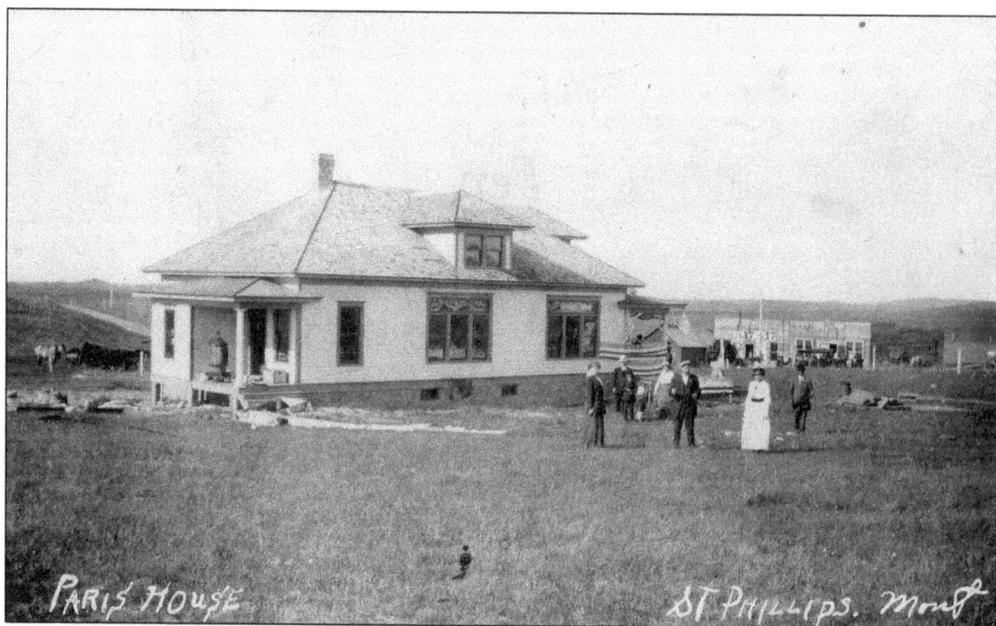

This is a photograph of the rectory of the church of St. Philip, located in St. Philip, Montana.

Bertha (Bojan) Peplinski's sister Suzie and her family are seen here. The young boy is Fr. David Ryszka.

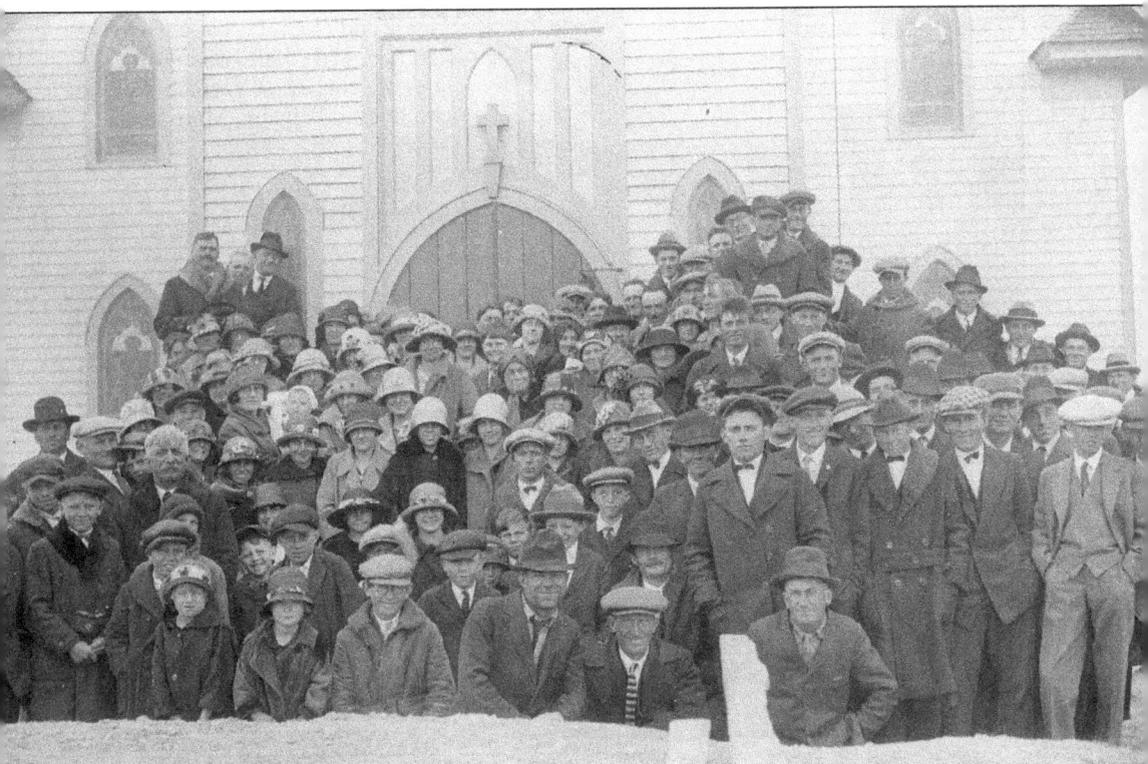

When the lumber mills closed in 1910, immigrants from Winona went west to try to make a living. Some stopped in North Dakota. Others, like the Losinski, Cierzan, and Wicka families, made their way to Montana. St. Philip Church in St. Philip, Montana, was built on land donated by Philip Wicka. Seen here are the original church and its members.

Sophie and Hermina Jereczek are seen here with their grandmother. They are cousins of Verna Sokoloski, who lives in Wibaux, Montana.

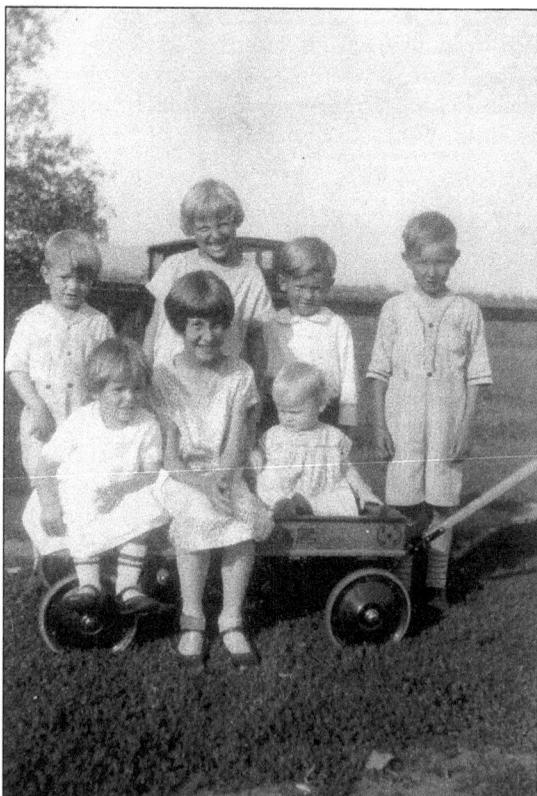

Photographed here is the Al and Frances Jereczek family. From left to right, they are as follows: (seated in wagon) Irene, Lenore (Mrs. Williams), and Helen Mary; (standing in back) David, Adeline, Edward, and Gene.

Antoine Bojan, pictured here, is Bertha (Bojan) Peplinski's brother. Bertha is a half-sister to Veronica Pehler of Winona. Bertha lived in Wibaux, Montana.

Mary and Tekla Burant are pictured here, probably with their mother.

The Wibaux (Montana) fair parade was held in 1994. This photograph was taken by J. Dobrowski.

Ted Olszewski, Florence Olszewski, Mary Ann Olszewski, Jacqueline Kranz, and Irving Kranz are seen here. Florence is 91 years of age here. Ted and Jacqueline are her children. They returned to the Polish Cultural Institute in 1996, to see their wagon that homesteaded into Hogeland, Montana.

www.ingramcontent.com/pod-product-compliance
Lightning Source LLC
Chambersburg PA
CBHW080859100426
42812CB00007B/2090